PAINT LIKE

THE **MASTERS**

BARRON'S

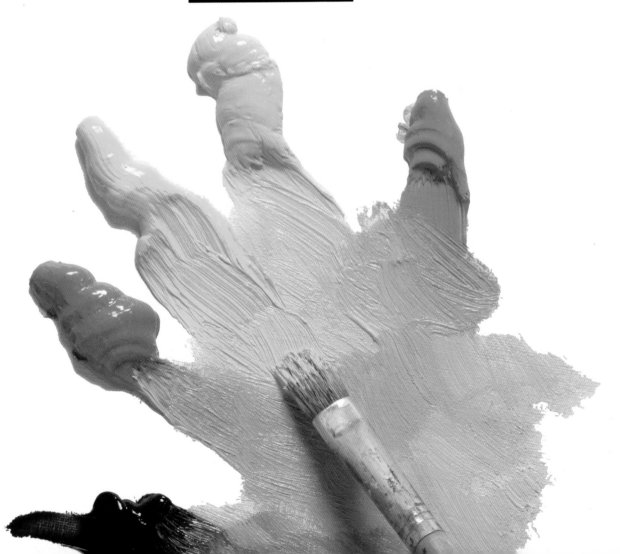

How to access
the interactive content

You can access the content through augmented reality or by registering on the web page:

• Through augmented reality

1. Download the free application AR for IOS at **http://www.books2AR.com/GMIOS** or for Android at **http://www.books2AR.com/GMAndroid**

Or through:

QR for IOS

QR for Android

2. Use the App to scan the image where you see one of these three icons:

Print. Gives you the opportunity to print the original work through an E-mail.

Video. Shows a specific process or technique in detail.

Watch. Shows you works by the same artist that were created using the same techniques.

• Through the web page

Sign up on the web page by registering for free at **www.books2AR.com/GM/US**, using the following code:

The App requires an Internet connection to access the multimedia content.

This is not only on one of the best know of art. Despite the app is powerful and dynamic as if the flowers were su not arranged haphazardly three quarters, profile, and alike. In short, this is a work France that Van Gogh adored

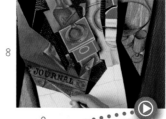

Chiaroscuro Effects

Next you will incorporate some very interesting textural effects like th wood grain and pointillism. Juan Gris used to represent these texture with *papers collées*, but we are going to recreate them in oils using a silicon shaper brush. The objects that make up the still life will emerge little by little as they are created using shading and modeling technique The elements are figurative and are easy to identify, even though they look fragmented, and each one of them is represented from a differen point of view: the fruit bowl and the cup from an elevated position, the coffee pot from the side, and the newspaper completely flat. Othe objects, like the coffee grinder, are so stylized that you have to use yo imagination to recognize them.

7

7. The objects begin appearing th to the monochromatic work done w a fine brush. You must proceed ver carefully so that you do not ruin the work by brushing it with your hand

8

8. Draw the letters of the newspap over a background of Veronese gre lightened with white. Use a gray to made by mixing Veronese green w permanent violet. Use the same mi to add the shadows on the green background. Watch the video to see the modeling of the objects is done the still-wet green.

9

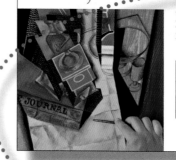

9. On the tablecloth, it is necessary to apply a layer of creamy white paint with a touch of ochre and gray, creating light tonal values. The shading is done with additions of gray and end with an overall sgraffito do with the handle end of the paintbrush.

It may not look like it, but in reality this is a very labor-intensive work, since most of the interventi require great precision and there is barely room few quick and spontaneous brushstrokes as in ot paintings in this book. Nevertheless, the result is impeccable and very close to the real model.

Video

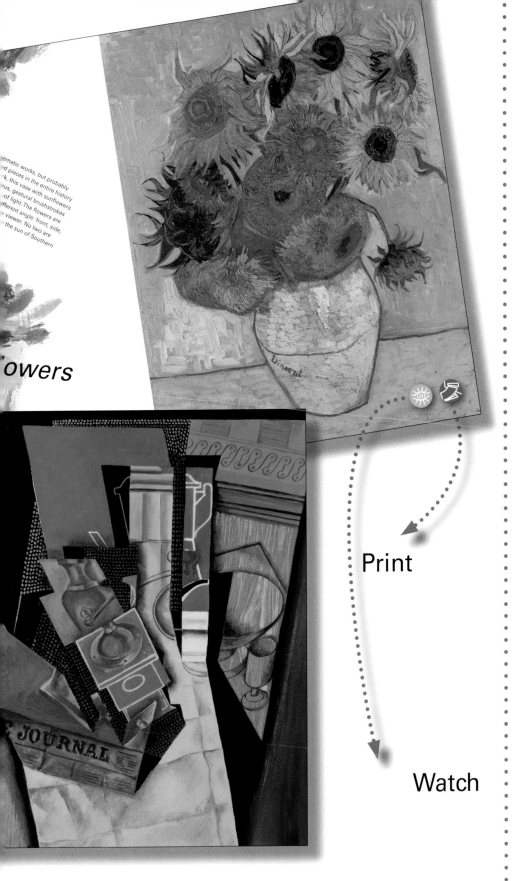

ematic works, but probably
d pieces in the entire history
k, this vase with sunflowers
us, gestural brushstrokes
or light. The flowers are
fferent angle: front, side,
e viewer. No two are
the sun of Southern

owers

 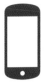

**Augmented reality
in three simple steps:**

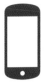

Download the Layar
app for free.

Scan the image
where you see
one of these icons.

Discover the interactive
content.

Print

Watch

Augmented
AReality

Enhanced Interactive Content Beyond the Book

Contents

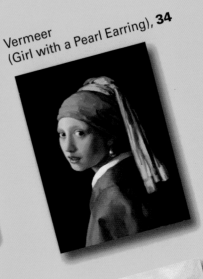

Imitating the Technique, **24**

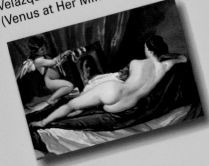

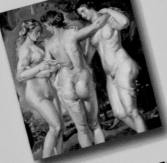

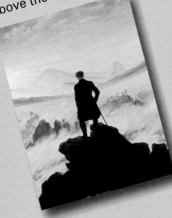
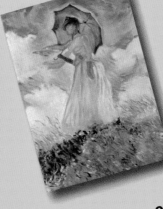
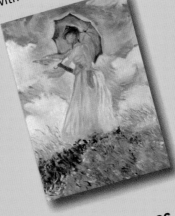
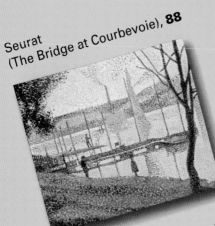
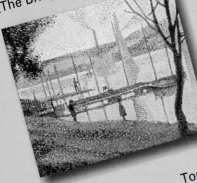
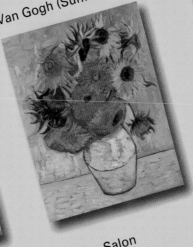
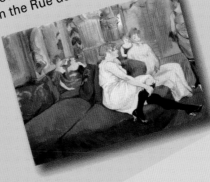
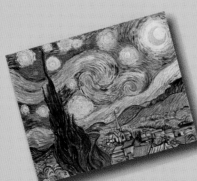
Patinas and Finishes, **136**

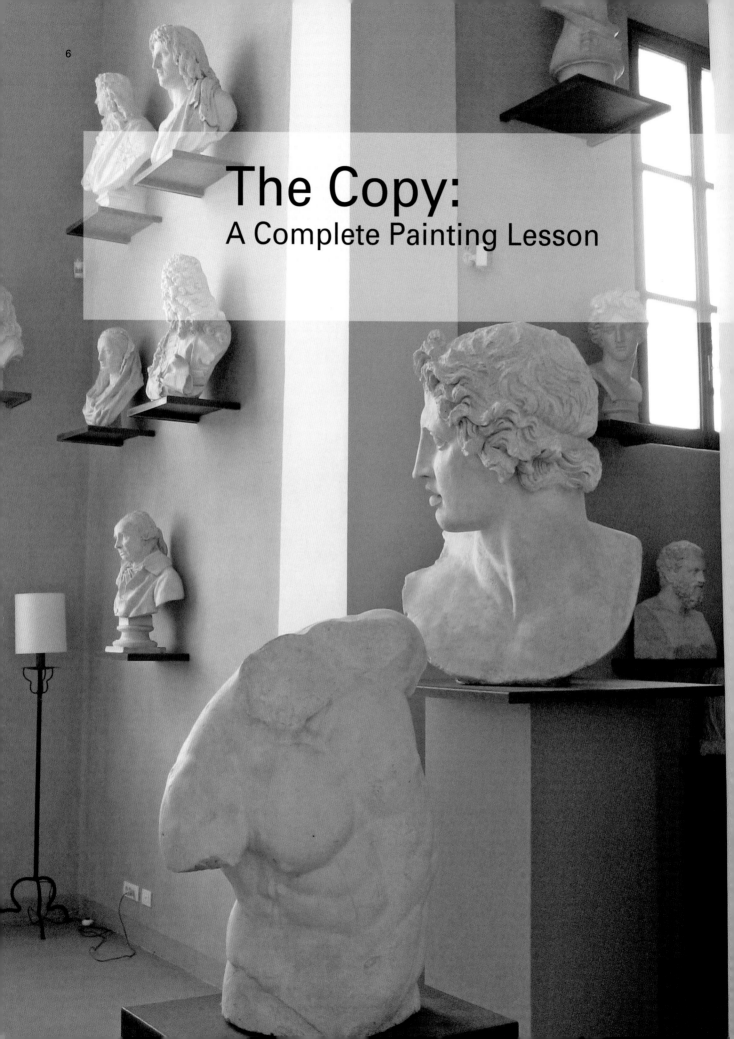

The Copy:
A Complete Painting Lesson

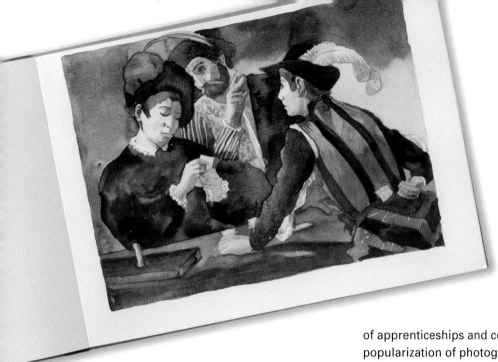

The rooms of the old academies and schools of art were full of copies of famous paintings and reproductions of classic sculptures cast in plaster. Replicas of the work of artists from the old days were the best way for the numerous and geographically dispersed public to be exposed to an individual piece of art. Although they were obviously not originals, the copies played an important role in spreading the art and work of ingenious creative artists.

From the 16th to the 19th centuries, very few artists had the opportunity to travel through Europe looking for original works of art to study, and most of them had to settle for painted replicas or printed engravings that reproduced the most celebrated works in black and white. The excellent reproductions in books about art that we now enjoy did not exist in those days.

During their period of training, nearly all the great artists copied the work of their predecessors and even other artists of their own era. Velazquez, Rubens, Goya, Ingres, Manet, and others did so without hesitation because of its learning value, and because they wanted to discover the secrets of the techniques. In those days, it was typical for an apprentice to copy the work of his master. Only as he progressed and acquired the necessary abilities did he participate in a more active manner in the projects being carried out by the master. Over time, he could aspire to becoming a master and founding his own studio, where he would be completely independent and able to sell his own work. With the decline of the academies of art and the appearance of the artistic *avante grade* at the beginning of the 20th century, the tradition

of apprenticeships and copying fell into disuse. The popularization of photographic techniques and the advances in four-color printing also were detrimental, and good color reproductions replaced the painted copies. Despite all this, the art of the copy still lives on among the unconditional lovers of classic painting, which has been maintained by several important institutions like the Prado Museum in Madrid, the Louvre Museum in Paris, the Uffizi Gallery in Florence, and the National Gallery in London, among others. All of them still allow the practice of copying in their regulations, with the goal of continuing the practice and making it possible to learn to paint by allowing amateurs to come face to face with original works of art. Because of this, copying directly from an original in the 21st century is now a pursuit that is enjoyed by some very strong devotees.

The halls of these museums once again are filled with copyists and artists looking to improve their techniques, imitating the brushstrokes of the great painting masters, or perhaps they simply have a strong desire to become better at this new art, a new genre. Their work is an act of admiring the painting, attempting to recreate the past in the spirit of love of beauty while acquiring the prestige that comes from possessing a copy of the original.

Copying famous paintings like those you will see in this book is an extraordinarily beneficial exercise requiring patience, a great amount of reflection, some ability, and a considerable knowledge of technique. It is not just a matter of replicating the painting of another painter by imitating his or her technique and brushstrokes; you must immerse yourself in the work and capture its soul. At the moment that one is able to capture the essence of a painting, copying becomes a true delight.

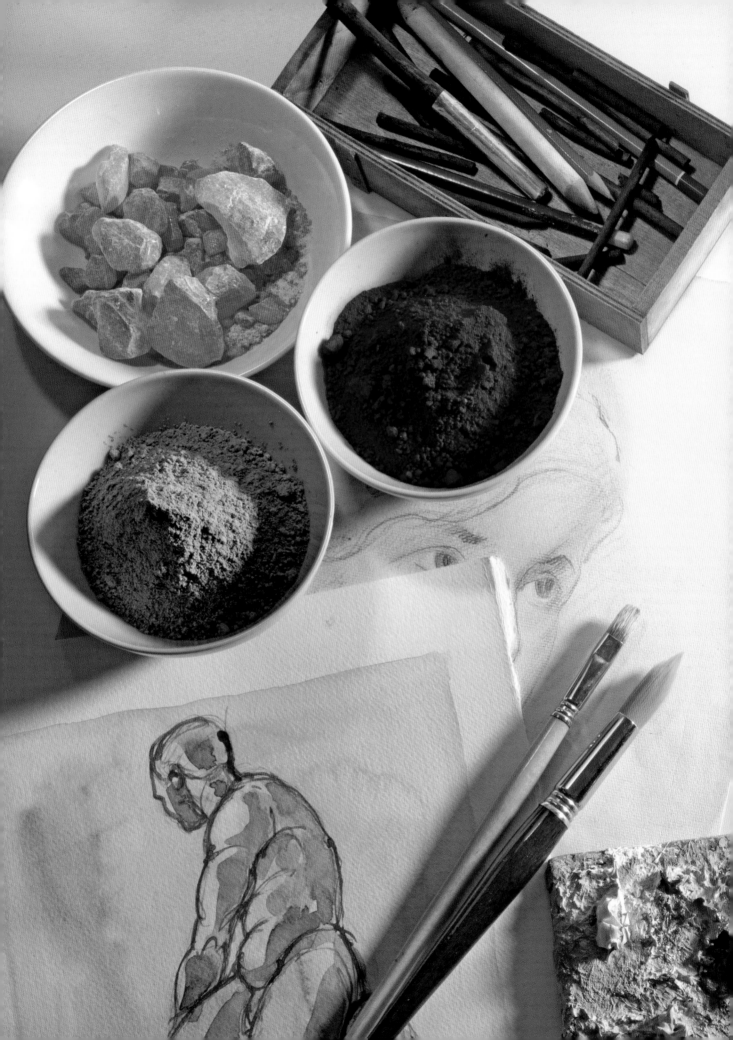

Copying

as a Painting Apprenticeship

Since the Renaissance, copying the works of the great masters was a usual system of apprenticeship in the studios and painting schools. In addition to being an effective teaching method, it was a way of becoming familiar with and getting inside an exceptional mind and learning the depth of the techniques and the processes carried out by the master. The goal of copying is not just duplication but also understanding, with the hope of gaining insight that will help you develop a personal vocabulary and point of view. However, to achieve satisfactory results, you must first learn about the materials, the supports, the paint, and the approaches that are necessary for creating a very accurate and precise initial drawing. Relating the proportions of the elements that are part of the painting to each other, and therefore resemblance to the original model, greatly depend on it.

Materials and Supports,
an Important Choice

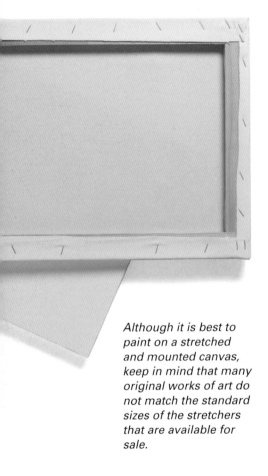

Before beginning to copy a painting, you must take the time to select the most appropriate support, which will be based on the medium you will use and the effect or painted finish you hope to achieve with it. A support that is prepared correctly for each case will significantly increase the possibility of a successful copy and will be helpful in performing such artisanal tasks as manipulating the paint with the brush and finishing the surface texture of the painting.

Fabric, Cardboard, and Wood

Fabric and canvas are the traditional supports for oil painting. Various materials are used in their manufacture, like jute, cotton, and linen, and they can be purchased mounted on a stretcher, covered with a layer of primer, and ready to paint. Other alternatives, like canvas boards, have similar qualities to both canvas on a stretcher and oil painting paper, which has a texture that simulates the woven texture of a canvas. These are much less expensive and less abrasive than canvas, and they have a waxy surface that allows the brush to slide over it easily. There is also the option of painting on plywood primed with several layers of white gesso. After the primer is dry you can create a smoother finish by sanding it with fine grain sandpaper.

Although it is best to paint on a stretched and mounted canvas, keep in mind that many original works of art do not match the standard sizes of the stretchers that are available for sale.

Some artists buy fabrics in bulk and mount them on stretchers that they buy unassembled. Others prefer to buy them already primed with a coat of gesso. There are different qualities and prices available in stores, depending on the weave of the fabric and the quality of the primer.

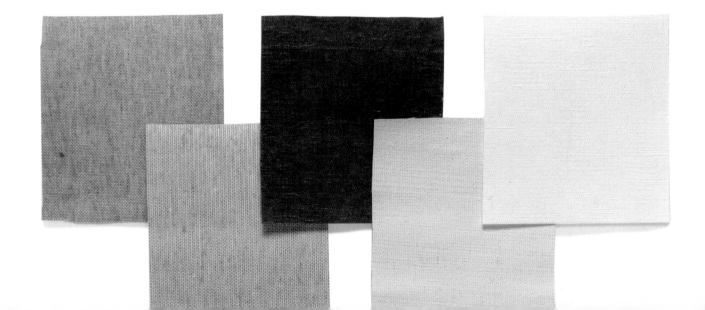

The Texture of the Fabric

The texture of the fabric basically depends on its weave and how it has been primed with gesso. Fabrics that you can buy already primed usually have different amounts of roughness, based on the size of its grain. If you are working with the dry brush technique, a textured canvas will be ideal; however, it will present a problem for modeling and applying glazes, which you can resolve by reducing the grain of the surface with several thin coats of gesso. The number of coats that you apply is up to you, as long as you create a smooth and level surface that is bright white. It is recommended to make the top layers thinner than the lower ones to prevent the effects of tension that are inherent in the paint and can cause grave problems.

When painting on plywood, there is a risk that it will warp. To avoid this, it is a good idea to apply the same layers of gesso on both sides of the board.

To cover the surface of the support you can spread a heavy coat of gesso, which will allow the marks of the brush to show. Rather than being an inconvenience, it can be a technique for adding texture to the copy.

GARLIC FOR POROSITY

If you are going to paint a work using mainly glazing, it is important that the surface of the fabric is not too porous. A very absorbent ground can soak up all the oil from the paint, leaving fragile, brittle pigment. Avoid this by applying a coat of gesso over the white commercially primed canvas, or by rubbing the surface with a clove of garlic, which will reduce the absorption of the paint.

The Preliminary Drawing,
a Literal Copy

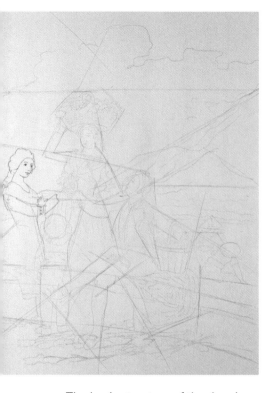

One of the main problems faced by copyists is transferring the dimensions of the real model to the scale of the support, while maintaining the correct proportions. The drawing of a copyist does not fulfill the same needs as one that is developed by an artist who is painting freely, who uses loose, personal, and expressive lines. The copyist must create a drawing that is more deliberate, accurate, and restrained, with little margin for error and that leaves little room for spontaneity and freedom. This means that the copy should be literal and show very few differences in respect to the original.

Aligning Points

The drawing must be very exact and maintain perfect proportions among all the components. It does not matter what medium you use to achieve such a goal, as long as you get the desired results. This means that in planning the drawing you can use methods that are as "antiartistic" as a light table, a slide projector, and tracing paper. You can also approach the drawing directly keeping in mind some compositional tricks, for example, using aligned points. This consists of locating horizontal, vertical, and diagonal reference points in the original painting that you can transfer to the canvas. They will help you create an accurate view of the structure, the outlines, and the distances. The ability to envision lines that pass through outlines and the basic forms in the work will help you create the preliminary drawing or blocking in.

The basic structure of the drawing can be laid out using aligned points or imaginary lines that coincide with specific outlines and forms in the original.

When the drawing is completed, the forms can be reinforced with lines, and the imaginary lines that were used to lay out the structure can be eliminated.

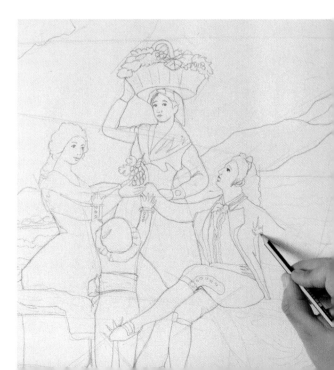

Compositional Schemes

If there is no way to make a tracing and you are drawing directly in front of the model, it is best to plan the composition by combining geometric shapes. You must synthesize each element in a sketch that is represented by a precise geometric form. Using this technique gives you complete control over the placement of the forms, the proportions, the balance of the surrounding empty spaces, and correctly adjusting the angles of the main lines that define the outlines of the bodies. Once you have laid out the basic geometric sketch, you can draw the model more accurately, just as you would if you used aligned points.

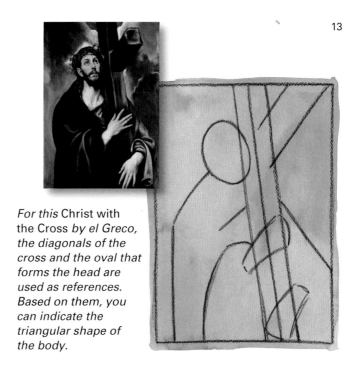

For this Christ with the Cross *by el Greco, the diagonals of the cross and the oval that forms the head are used as references. Based on them, you can indicate the triangular shape of the body.*

In this still life by Cézanne, we use two diagonal lines in a cross to locate one of the apples that is in the exact center of the painting. This is the starting point for laying out the rest of the curved and circular shapes.

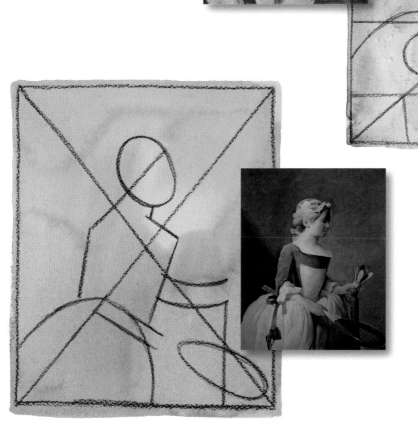

This figure by Chardon is also begun with two diagonal crossing lines that not only indicate the center of the painting but also outline the space occupied by the head and emphasize the inclination of the body.

Enlarging
with a Grid and a Projector

The use of lenses and systems of projecting light on a support is not at all rare in the history of painting. For example, some of the Baroque painters of the 16th and 17th centuries used the camera obscura to project the model onto their support. In the art of copying there is no reason to disdain any type of mechanical help for making a precise drawing; a grid on acetate, a light table, or a projector are all very valuable tools that allow you to replicate a model with little margin of error.

Using a Grid for Drawing

Good proportions, indicating the shapes, and generally organizing the drawing, are all easier to achieve if you have the help of templates or a grid. The grid is a linear screen that allows you to compare lines, calculate distances, and adjust proportions. Thus, the drawing can be easier and more accurate if it is made on a paper with guidelines. To faithfully transfer an image to a drawing, draw two grids, one on the photograph of the model and one on the support that you are going to use for the painting. The grids should have the same number and positioning of the squares, whether or not they are the same size. You will erase the lines of the grid after the drawing is finished.

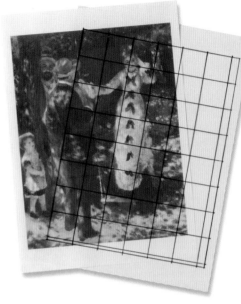

If you do not want to damage the reproduction, you can draw the grid on a piece of acetate and lay it over the image.

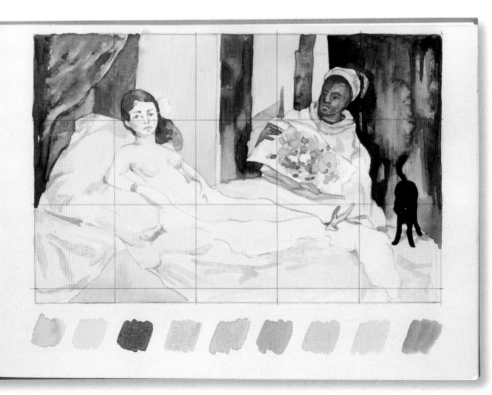

In this copy of a watercolor by Manet, the grid helped with making the drawing. Since it was made in pencil, you can erase it with a rubber eraser after the paint has completely dried.

Using the Projector

The use of optical systems and technology when laying out the drawing might make you wonder about the use of light tables and projectors in painting. Can using a projector be considered fair play? Of course, as long as you keep in mind that the goal of a copy is not to show off your creativity but to achieve the closest possible likeness to the original. These mechanical aids are generally used when the drawing is very complex, of great size, or extremely ornate and detailed. Some of the projectors on the market are specially designed for designers and illustrators and can be seen as an investment for someone who plans to use it a lot. There are, however, more economical alternatives, like a slide projector or an opaque projector.

Light tables make it easier to trace a model, but this technique will not be of help when painting on canvas because it requires working on paper.

Old slide projectors cast very sharp and clear images, which will allow you to reproduce any painting at any size you wish.

REVERSED IMAGES

One consequence of using lenses experienced by some Baroque artists was that the original image was reversed. This occurred, for example, with the representation of Bacchus *by Caravaggio, which shows the subject holding a glass in his left hand because the lenses that the artist used for making the drawing reflected a mirror image of the model, who was holding it in his right.*

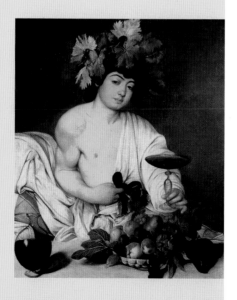

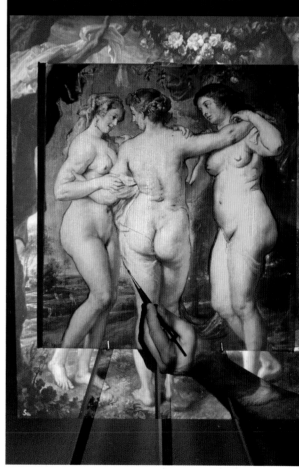

Nowadays, there are LED and HD projectors that can be connected to any computer. In addition to their other benefits, they can be used to help you trace any painting you wish to copy.

Tracing the Image
and Color Sketches

A

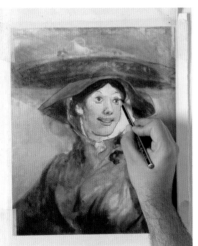

B

Tracing is often used when working with very complex models, since it helps keep the artist from making errors when laying out the drawing. First, the back of the paper is covered with a reproduction of the model, and then the artist traces the outlines of the shapes with a sharpened pencil to transfer the marks to the support on which the painting will be made. This preliminary drawing can be complemented with a few additions of color to make a light color value study.

Tracing with Graphite

To make a tracing, you will need a copy of the model on paper, of the same size as the support on which it will be painted. Cover the back of the drawing with graphite, applying pressure and completely covering it with a thin layer of gray. Place the paper on the support and attach it with tape so that it will not move while tracing. Use a sharpened pencil to follow the outlines of the shapes of the model, making a clear line drawing on the support. When the tracing is finished, remove the paper and make sure that the drawing has transferred to the fabric. It is a good idea to go over the drawing to make sure that no areas have been left out. If they have, they can be corrected by completing the lines directly with the pencil.

C

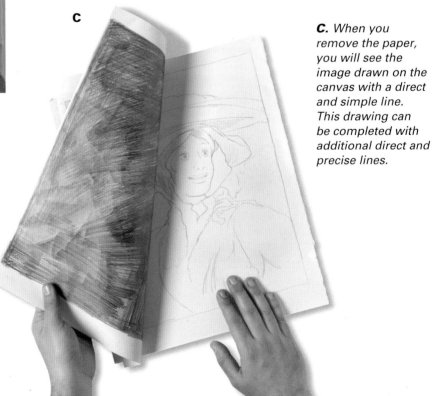

A. Start with a photographic enlargement of the model in black and white. Turn the paper over and use a graphite pencil to completely cover the surface with dark shading.

B. Place the photograph on the support, making sure it is lined up correctly, and fix it in place with adhesive tape. Use the same pencil to go over the outlines of the figure.

C. When you remove the paper, you will see the image drawn on the canvas with a direct and simple line. This drawing can be completed with additional direct and precise lines.

Color Sketches

When faced with the challenge of making an important work of art that is rich in colors, very detailed, and well modeled, it is a good idea to make several sketches or color notes beforehand where you can try out the color palette that will be used. It is not necessary to make the notes using the same media that will be used to create the painting. A small watercolor sketchbook or a piece of cardboard are enough for making some quick watercolors that will help you work out the techniques and coherence of the colors of the model. Copying does not necessarily mean always making works of great size; you can also get beautiful results painting watercolors and oils in small formats.

Color sketch made with oil glazes treated with oil painting medium, which would correspond to the first layers of color in the process of making this painting.

This is a preliminary study, with color charts, of a famous country scene by the British artist John Constable. The small format and the watercolors work very well when you desire very accurate colors and a work rich in details.

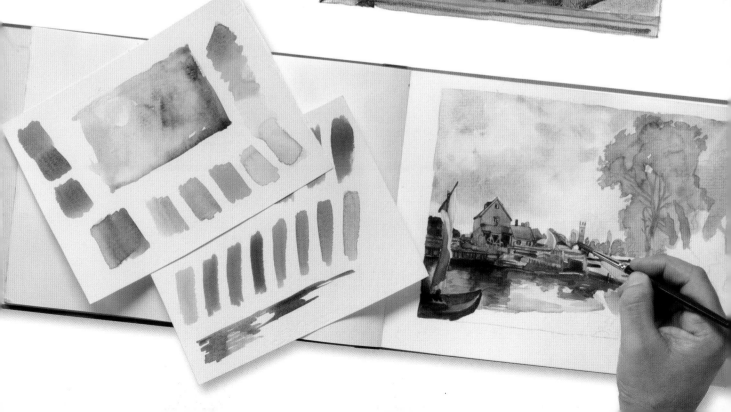

Underpainting
and Primer

Beginning a painting on a white background is a relatively recent practice that became popular during the Impressionist period at the end of the 19th century. Up until then, artists always painted on backgrounds that were first colored or tinted. The goal of this underpainting was to create a general undertone, a base color of medium intensity that could be painted over with both light colors and dark colors, both of them being visible because of the contrast created by the background.

Smooth and Textured White Primer

Although canvases can be bought already primed with a coat of sizing or white glue, you do not have to settle for them. The coating or primer can be easily altered, depending on the desired background texture and how you are going to use the brush. The thinnest layers are created by applying coats of gesso that are then smoothed with fine sandpaper. This will make the background color look even. Gesso that is applied more heavily and without sanding creates hollows and streaks where the pigment in the first diluted applications will be deposited, creating a base of textured color.

Gesso and mediums like oil painting medium are often used for preparing the canvas and spreading the first washes of color that are used for the underpainting.

A. Dilute the oil paint with a little varnish and apply a color wash to the canvas. The color, however uniform, will look granular because of the texture of the fabric.

B. It is possible to alter the look of the underpainting with thick gesso. Applying brushstrokes in the same direction will cause the paint to collect in the streaks.

C. A few coats of gesso can also reduce the texture of the support. When the material is completely dry, rub it several times with fine sandpaper. When you paint over it, the wash will look more uniform.

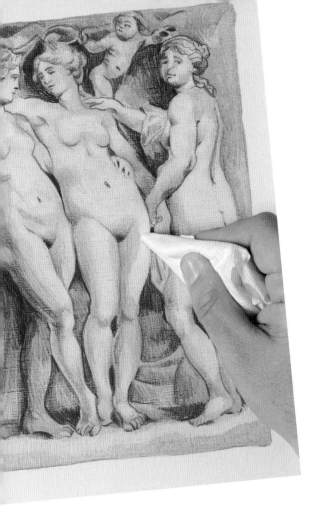

Color Backgrounds

The advantages of painting on colored backgrounds are so great that it is surprising to find an artist from the past who did not work this way. From the beginning of the 16th century to the 19th century most artists used colored backgrounds, which were nearly always composed of dark and medium earth tones like ochre, sienna, English red, and grays with a blue or brown tendency. Rembrandt started his paintings with a "dead color," something like the one used for grisaille; Vermeer used blue and brownish glazes; and Rubens applied a layer of the earth tone raw sienna. This first coat of paint, to which was added a little varnish, sealed the porosity of the gesso so it would not absorb the oil paint. Some artists lightened areas by wiping them with a cotton rag, resulting in a first layer of translucent paint with some highlighted areas on the figures.

This is a copy of a preliminary study of Rubens' The Three Graces, which shows how you can brighten or lighten the overall background color by wiping it with a clean cloth to emphasize the lightest areas.

After you have made the drawing, cover the background with a brown color to lessen the brightness of the white support. The paint can be diluted with turpentine or some type of varnish to reduce its drying time.

Working on a background with underpainting is not the same as painting on a white support. A medium tone background favors both the incorporation of dark colors and light colors from the outset of the work.

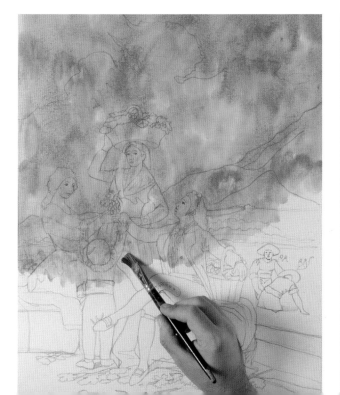

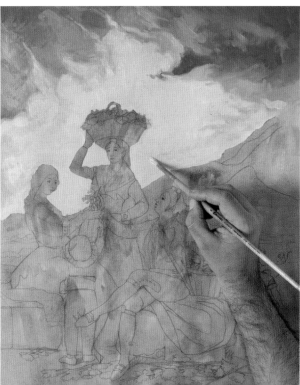

The Exact Color:
Adjusting the Tones with Samples

The color palette is one of the aspects that best define the work of an artist and even the style of an era. An artist who hopes to emulate the paintings of the great masters must be able to reproduce palettes unlike his or her own, be accurate in the use of tones that suggest the work that is being reproduced, and understand what colors are used in the mixtures and what techniques were used to lighten and darken a color. In this section, we offer a very simple exercise that will help you study color in a precise and individualized way, outside the context of the painting, so you can acquire the needed skill to create the most accurate tones by trying to imitate the exact colors of some fragments taken from the magnificent painting *The Penitent Magdalene* by el Greco.

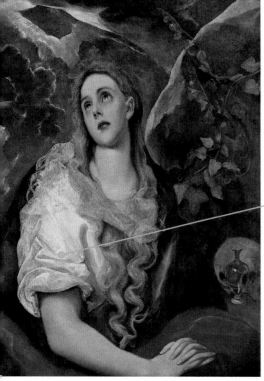

This exercise can be done with any painting, in this case we are using The Penitent Magdalene *painted by el Greco, from which we have selected a few details. You can enlarge it with a computer to make a good print or make color photocopies of these details.*

Each detail should contain two or three different colors and a variety of brushstrokes. The printed samples on paper should be glued with latex glue to a support that can be painted with oils. These cutouts will be used as samples or references for developing the artist's palette.

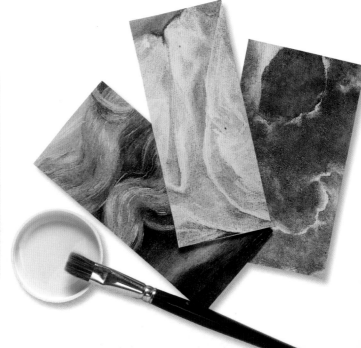

Now it is a matter of taking a palette with oil colors on it and reproducing the tones of the masters, with much mixing of the shades. Paint on both sides of the printed cutout, following the folds of the clothing, the texture of the hair, or the wispiness of the clouds. You must pay close attention to the range of colors used by the artist: titanium white, ochre, burnt umber, burnt sienna, raw sienna, permanent violet, Prussian blue, alizarin crimson, and yellow ochre.

A. *In the first mixture, use ultramarine blue, titanium white, a gray made by adding burnt umber to blue, and a touch of violet. The paint should be added right beside the printed sample to make sure that your strokes match its color.*

B. *To adjust the tones of this sample, you need violet, titanium white, burnt umber, raw sienna, yellow ochre, and a touch of crimson (for the orange tones). Here it is not enough to just match the colors, you must also create the texture of the hair using the tip of the paintbrush.*

C. *The burnt umber is used to darken the Prussian blue and yellow ochre in the strand of hair. The exercise is completed with light violet and blue in the lightest areas. The brushstrokes should be wavy like the folds of the fabric and the hair.*

D. *The clouds in the sky are created with Prussian blue, lightened with titanium white, violet, and burnt sienna. It is a matter of giving the broken forms in the sky a continuity with a mottled or streaky brushstroke that reflects the texture in the clouds.*

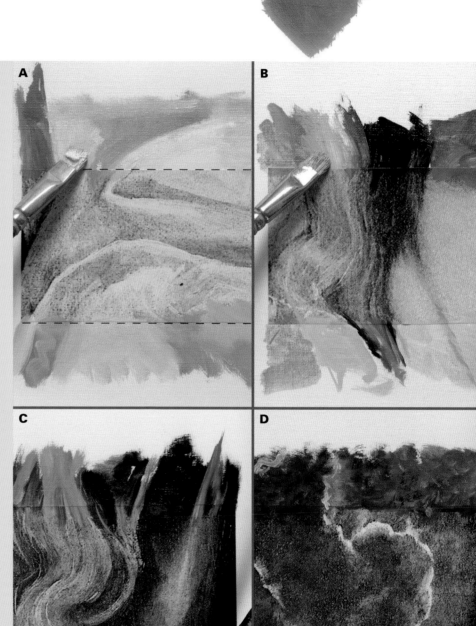

The Palette
and Treatment with Brushstrokes

The different ranges of color that artists used in their paintings are known as their palette. In the old days, the palettes did not have as many colors as those of today, since the range was much more limited, and to a great extent depended on the importation of natural pigments, which usually came from very distant parts of the world. This meant that, in the 16th century, a painter who had a studio in London did not have the same colors as one who lived in Venice, a Mediterranean port where rich and varied pigments imported from Asia were available.

Many of the pigments used by the old artists have been replaced by new ones that are synthetic, more permanent, and less toxic.

A. Oil diluted with oil painting medium creates a very watery, translucent color.

B. Paint slightly diluted with turpentine produces color that is dense and homogenous, easy to blend with adjacent colors.

C. Oils can be thickened with a little linseed oil, which will make the brush marks more visible.

The Palettes of the Old Days

The most typical and common of the palettes is composed of very few colors; generally, the ones known as the primaries: black, white, yellow ochre, dark ochre, red ochre, and sienna (vermilion was kept separate), combined with other more exotic colors like lapis lazuli (ultramarine blue). In the 19th century, new synthetic pigments were discovered, and the palette was considerably enlarged, so that artists began using about 20 different colors. Today, the main difficulty confronting the copyist who wishes to meticulously reproduce the work of the great artists of the past is that most of the old pigments are no longer used, having been replaced by products that are chemically purer and much more solid, like the cadmium sulfides and the chrome oxides, which are healthier than other old pigments derived from lead, mercury, and copper.

A

B

C

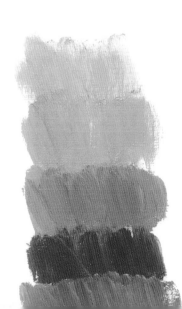

Painting Techniques

Before starting to copy a painting, it is a good idea to acquire a good reproduction of the original, which will allow you to easily study how the artist applied the paint to the canvas, and simply try to imitate it. The amount of paint, its thickness, the angle of the brush, and the stroke made by the hand are important in reproducing the artist's technique and style. It is important to practice with some exercises in oil to prepare yourself for all kinds of unforeseen problems that may arise. You can begin with paint diluted with varnish, applying a light glaze on the canvas (A); applying opaque paint with the colors blended with each other (B); adding strokes of thick undiluted paint (C); drybrushing on a textured surface (D); applying impasto with a round brush held sideways (E); and dragging streaky bands of paint with a spatula (F).

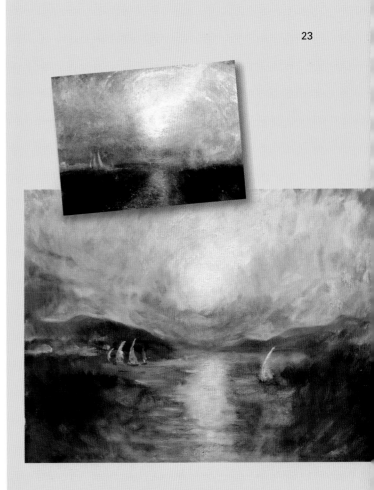

D. *The drybrush technique is done with very thick paint that has not been diluted. This is ideal if you wish to only partially cover the white of the support.*

E. *When the colors are partially mixed on the palette and applied with a round brush, the result is a striated or streaky brushstroke that is appropriate for expressionistic paintings.*

F. *The spatula is used to drag the paint, which creates thin bands. The result is not very precise, but very textured and attractive.*

COPY OR PASTICHE?

Pastiche, a word that comes from the original Italian pasticcio, is a free copy of the model, that is, either an informal copy of the painting in question or the appropriation of the artist's style to create a new work. It is not a matter, then, of a literal copy, but just of copying the artist's style to create a new work or something similar to the original, as in this example inspired by an oil painting by William Turner.

D

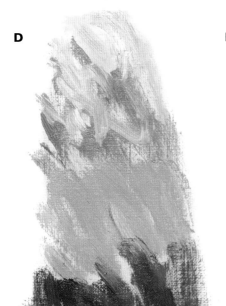

E

F

Imitating the Technique

Copying is one of the best techniques for learning to see because it forces you to carefully observe the original so you can identify the way the artist went about applying each brushstroke and area of color on the support. However, the challenge of faithfully copying a painting entails many problems related to how to begin: knowing if the preliminary marks are made in the same way as the definitive ones; if the finishes with glazes alter the final colors; with what brush, angle, and pressure the paint should be applied; when the brushstroke should be slow and sinuous, or quick and agitated. These and other questions are answered throughout the following exercises, where you will be copying master works from different periods and styles, looking at certain details concerning style, use of color, and techniques for mixing and applying paint to the canvas, all with a simple and understandable approach.

In the following exercise you will paint a still life by Michelangelo Merissa da Caravaggio (1571–1610), one of the great masters of the Italian Baroque period. It is a wicker basket that contains a collection of fruit arranged harmoniously. The dark tones of the black grapes and the dull greens of the leaves alternate with the warmer and brighter colors of the rest of the fruit. The white background emphasizes the silhouette of the forms and focuses all the attention on the basket, which is located very near to the viewer.

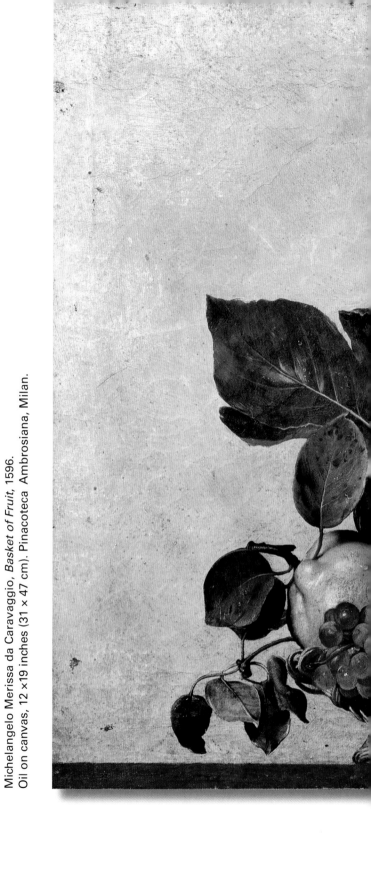

Michelangelo Merissa da Caravaggio, *Basket of Fruit*, 1596. Oil on canvas, 12 ×19 inches (31 × 47 cm). Pinacoteca Ambrosiana, Milan.

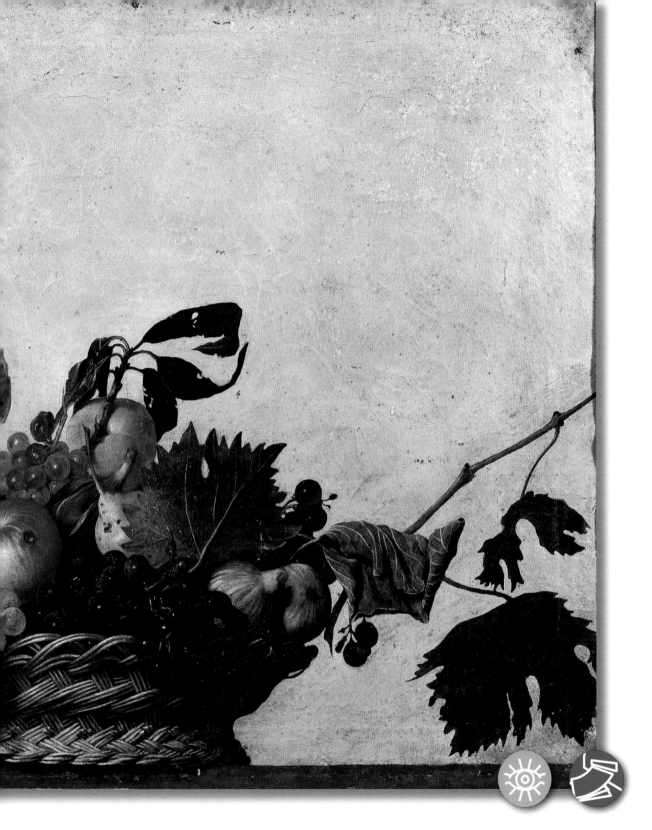

Basket of Fruit
by **Caravaggio**

I

A Precise Line Drawing

You will be representing this still life on a white primed canvas. A recent study of the original work using X-ray technology has shown that the picture was painted on a canvas previously used by Caravaggio, and covered sometime later with a uniform layer of paint. Caravaggio was such an accomplished draughtsman that in his paintings he drew just a few basic lines with the tip of the handle of his brush, he barely made any preparatory sketches or notes. However, because not all artists are masters nor do they have the drawing skills of Caravaggio, we are going to base this exercise on a preliminary drawing that is solid and precise made with a stick of charcoal.

1. The first step is to find a good reproduction of the painting, scan it, and print it on a sheet of 11 × 17 inch (A3 size) paper. Then fold the paper several times until the folds form a grid to help block in all the elements and to more easily control the proportions.

2. Make a very light preliminary drawing with a stick of charcoal. Continue to erase and correct the lines with a clean cotton rag. The result should be clean and the proportions should match those of the model.

3. Use a ruler to ensure that the drawing is adjusted to the measurements created by the grid on the photograph of the painting. You do not have to project all of the lines, it will be enough to mark the intersections with a small cross.

2

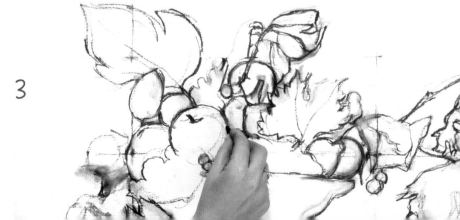

3

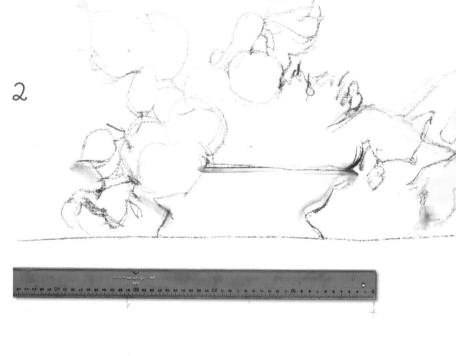

A RIGID BASE BEHIND THE FABRIC

When drawing on the canvas, some artists prefer to put a rigid board behind the stretcher so that they do not have to apply too much pressure on the charcoal stick or so that the pencil point does not leave grooves on the fabric.

4. The line work should be completed with light shading carried out with a blending stick. First apply some hatch marks with the charcoal, then blend and model them with the tip of the blending stick.

5. The initial drawing has a feeling of volume thanks to the shading. Some areas have a darker gray, whereas you can barely see the outlines of others. Before starting to paint, you will find it helpful to fix the charcoal lines well with a spray fixative.

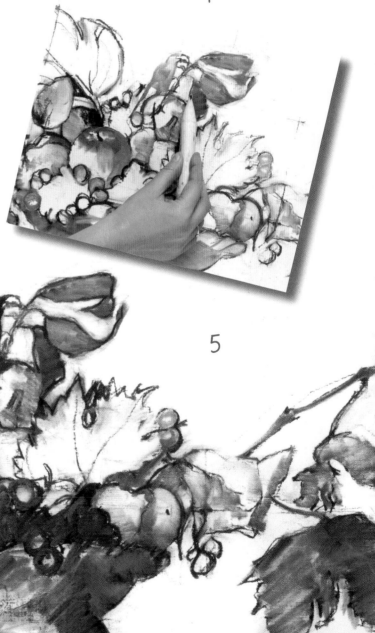

Resolving the Foreground

Caravaggio applied the first colors very quickly, applying the basic ones on each of the elements of the painting in a loose but accurate manner with the dual purpose of fixing the charcoal while beginning the task of representing the volume of the represented objects. The oil paint should not be applied too diluted or flat because you must begin to indicate the contrasts, darkening the shadows and transforming the object in a focus of light that will become more and more intense.

6

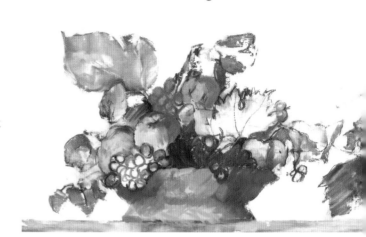

6. Use yellow ochre and a little burnt sienna to cover the wicker basket. The color will darken when it picks up some of the charcoal dust that is underneath. Begin painting the first pieces of fruit with cadmium orange, cadmium yellow, and yellow ochre.

7. Do not use black directly from the tube; it is better to make your own on the palette with a mixture of burnt umber and Prussian blue. Apply gray and violet tones on the darker bunches of grapes and finish the apple in the middle with cadmium red.

8. On the fruit, the brushstrokes should be curved and used to model the surface. The lighter bunches of grapes should be painted by alternating applications of light violet, other brown colors, and even crimson.

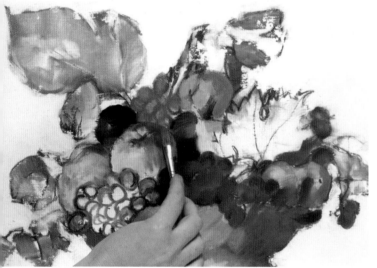

7

The first colors on the fruit should be modeled with further applications that shade and darken the chiaroscuro effect.

8

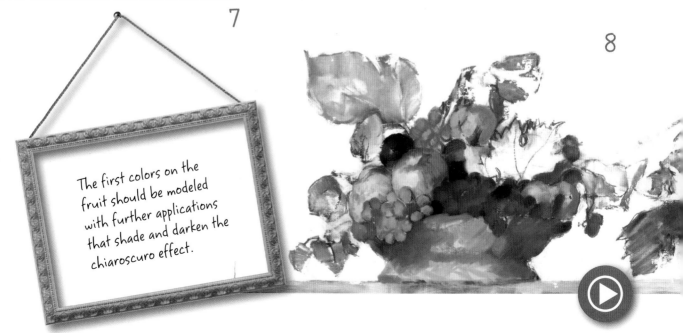

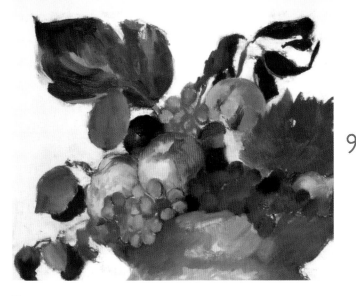

9

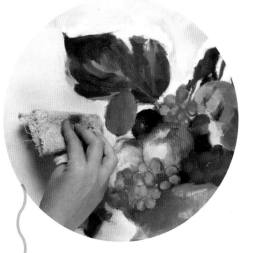

9. With a mixture of emerald green and sap green, darkened with ochre, cobalt blue, and white, you can achieve a wide variety of tones that you can use for painting the first colors of the leaves. The treatment should be loose and the application of the paint quick.

WORKING WITH A RAG

The rag is not only used here to clean the palette or dry the brushes; conveniently folded, it can be used to wipe and blend the colors on the support, eliminating any trace of the brush marks.

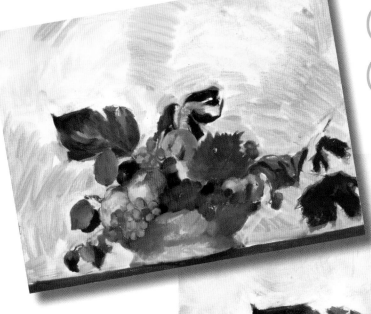

10

11

10. Create a mixture of dark Naples yellow, sienna, and a touch of green, and apply strokes with a brush that is barely charged with paint to the background. The brushstrokes are transparent, and you will see the brush marks on the support.

11. Blend the brushstrokes covering the background with a rag, pressing very lightly, and making circular motions that create a watercolor effect. Salmon tones dominate the background.

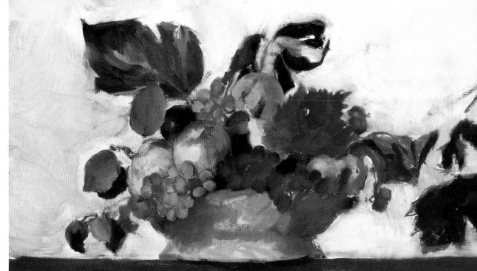

Finishing the Fruit Basket

In this final phase you should be working on the fruit in greater detail, strengthening the contrast between the light and shadow, focusing on the details and textures, so that the basket will seem to rock on the edge of the pictorial space, as if it were advancing toward the viewer. This *trompe l'oeil* approach, strengthened by an extraordinary realism, should be the main goal as you finish this painting. You must detail the dry, withering fruit with their blemishes and holes as well as the healthy fresh pieces of fruit. The same is true for the leaves; some are green and shiny, and next to them are others that are wilting and wrinkled, yellowed and eaten by insects.

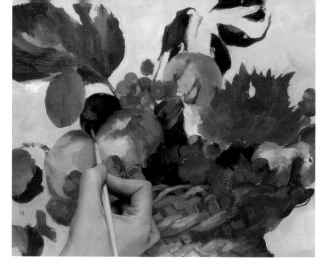

12

12. In the final phases of the work you will use a fine round brush. This will allow you to focus on each of the individual pieces of fruit. It is a matter of reproducing the details with all their chromatic richness, their highlights, their texture and even their imperfections.

13

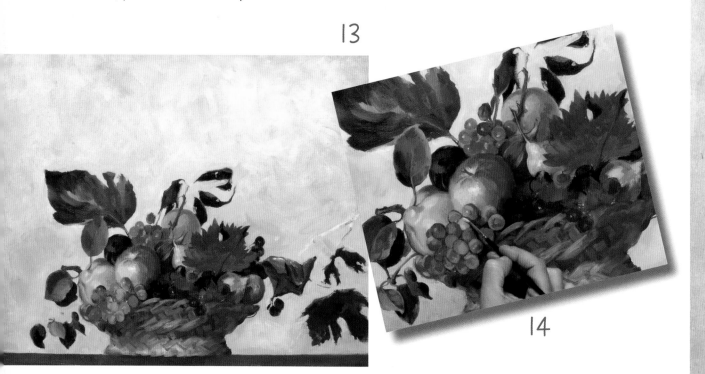

14

13. The modeling of the shadows and the delicate brushstrokes that follow the curvature of the surfaces create a greater sense of volume on the pieces of fruit, which little by little seem to emerge from the surface of the painting.

14. Each grape should be treated individually, as if it were a small sphere affected by different lighting conditions and its own particular coloring. The reflections of light are not white, but rather a very light violet.

The final brushstrokes must be the most precise; they are used to add small details, to define the imperfect texture of the fruit and leaves, some full and others with holes and discolored. You must constantly make comparisons between your work and the real model so you can continually make adjustments to the differences.

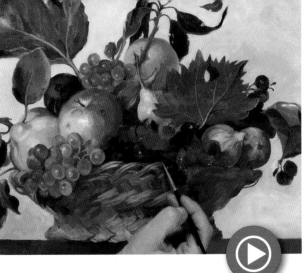

15

15. The same interest in depicting the details on the pieces of fruit can now be extended to the leaves, which look bent, tortured, and full of holes. Work on the textures of the basket and the apple should become more focused and show some of the holes and imperfections.

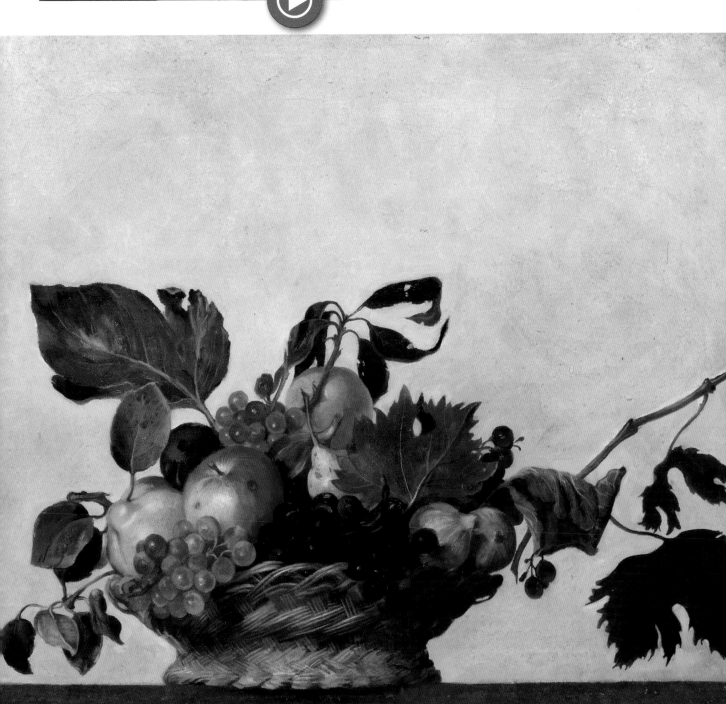

Girl with a Pearl Earring

by Vermeer

The Dutch painter Johannes Vermeer (1632–1675) became famous for his depiction of light in his paintings of interiors, the way it falls on the figures and the way he was able to model their flesh tones. Girl with a Pearl Earring, also referred to as the Dutch Mona Lisa and Girl in a Turban, despite being a small painting, is one of his most representative paintings and also most reproduced by students of the fine arts.

Johannes Vermeer, Girl with a Pearl Earring, ca. 1665–1667. Oil on canvas, 17.5 × 15 inches (44.5 × 39 cm). Mauritshuis, The Hague.

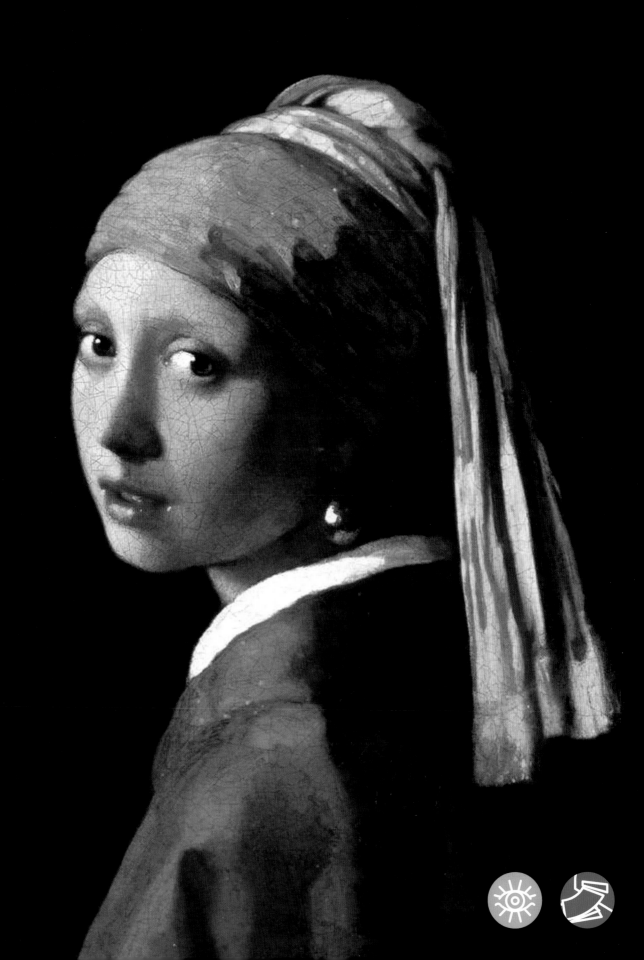

Geometric Structures

The first phase of the work is blocking in, drawing the model on the surface of the canvas. The method employed here is laying out the positions of the head and torso using simple geometric forms. The composition can be basically indicated with a couple of diagonal lines and a circle. It is very important that these forms are accurately positioned so that the figure occupies the correct place and is not moved too far to one side or the other.

2

1. All the great artists of the Baroque period began their paintings on a background with a medium or dark neutral color. This time we will use a blue gray on which the range of earth and flesh tones, which predominate here, will stand out.

3

2. Since we are working with a model that does not have a complicated composition, it is laid out with straight lines and circular shapes in charcoal. The horizontal and diagonal lines help locate the exact point where the head is placed, which is indicated with a circle.

3. Start drawing in the shapes of the figure over the initial sketch: the turban, the oval of the head, the neck, and the torso. The head is not centered in the canvas, but slightly higher, leaving quite a large empty space on the left.

4. After the figure is sketched in, it is time to create a more accurate drawing. Do not be afraid of making a mistake because the charcoal line can be easily erased by simply wiping it with a rag, no matter how wet the diluted paint background may be.

5. Use a clean rag to remove the initial structural lines and to make a first pass at lightening the most illuminated parts of the figure. When you wipe it with the rag, it will absorb some of the paint and leave a very thin layer of color that shows the white of the support.

6. Making the light areas on the layer of diluted paint is the first step in creating the contrasts that suggest the sense of volume.

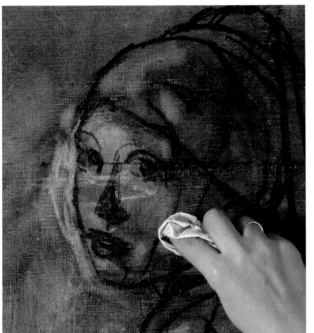

5

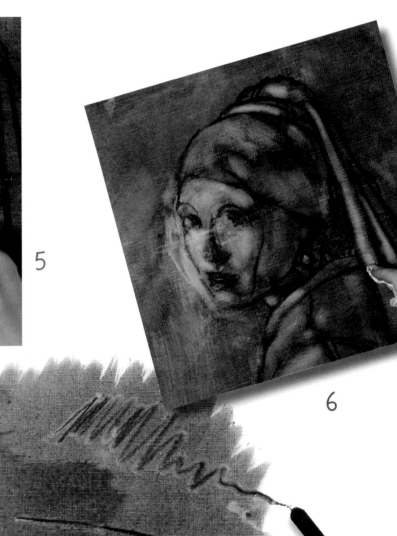

6

CHARCOAL OVER DILUTED PAINT

You can easily draw with charcoal over a background of diluted paint, but you must be careful to begin with a light line, and only darken it when it needs to be reinforced.

The Artist's Colors

Examining the basic pigments used in this work by Vermeer will help direct your selection of colors that will be used in this exercise. You will have to make just a few modifications to adapt the old paint colors to new ones that are available for purchase. The palette for this project is composed of titanium white, yellow ochre, red ochre (replaced with cadmium orange), chrome green, raw sienna, raw umber, and cobalt blue. It is a very minimal palette, simple and with nearly pure colors based on a combination of pinks, blues, and yellows.

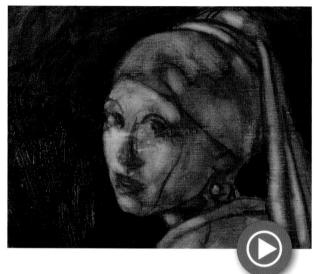

7

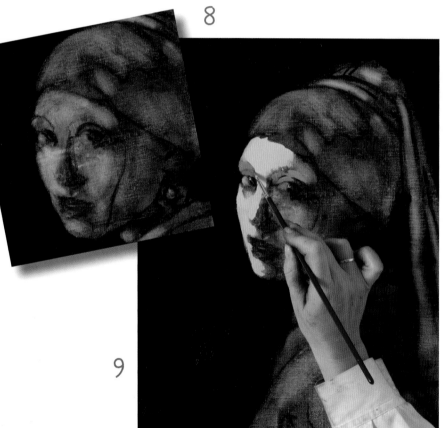

8

9

7. Paint the dark background with a mixture of cobalt blue and raw umber. Apply the paint in rather thick layers. The neutral background will contrast with the face and emphasize the three-dimensional effect of the figure. In the video, you can see how the background is darkened to silhouette the figure.

8. The thick, dense oil paint shows the streaks and marks left by the bristles of the brush on the surface of the paint. They should be removed by wiping your fingertips across the fresh paint. It is important to immediately wash your hands well with soap.

9. Start painting the face with a small amount of very light ochre and raw sienna that is mixed with a lot of white, but with less in the cavities of the eyes. First define the outside edge of the face, which will contrast and stand out very sharply against the dark background.

THE COLORS USED

This is the palette with the conveniently arranged colors that are used to reproduce this work of art: titanium white, yellow ochre, cadmium orange, raw sienna, chrome green, raw umber, and cobalt blue.

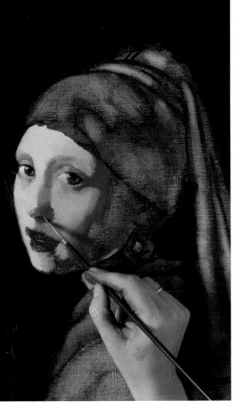

10

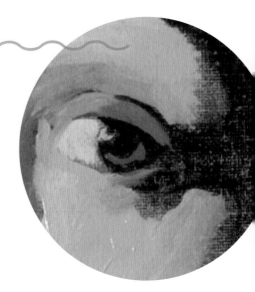

THE EYE OF THE FIGURE

This enlargement of the right eye will allow you to more clearly see how it is painted. First, the iris is created with a mixture of cobalt blue and raw sienna; then a curved line is drawn at the lower part, lightened with a green made by mixing cobalt blue and ochre. Next, the white of the eye is painted, and a small dab of white is applied on the iris to give it brightness.

10. The sense of the volume of the face is completed by adding some shadows at the base of the nose and on the right half of the face. A very satisfactory gray can be made by mixing raw umber, cobalt blue, and white, which should be lightly blended with the flesh tone after each application.

11. To finish the young woman's face, you must pay close attention to this sequence of three pictures that show the evolution of the model. On the right half of the face, the initial gray is covered with the earth tone raw sienna mixed with a touch of gray and orange. This can be darkened with umber.

12. Paint the girl's lips using cadmium orange mixed with raw sienna and a touch of blue. The slightly darker upper lip has a whitish highlight. Use a very light flesh tone to brighten the area around the mouth.

13. Pass a dry brush with soft hair over the face several times to create a more gradual blending that is more in line with the soft smooth skin of a young person. Repeat this light blending around the eyes.

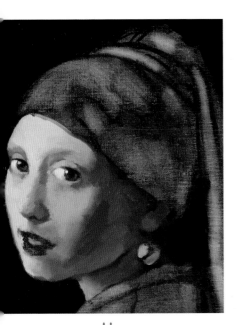

11

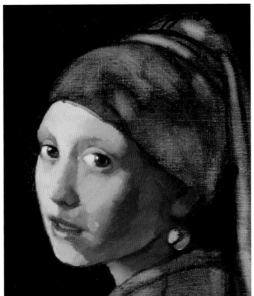

12

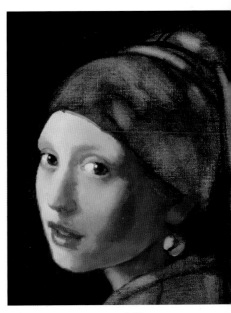

13

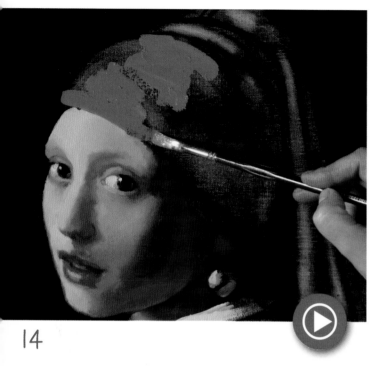

14

Dense Paint

Now it is time to address the clothing and the turban on her head. At first glance the turban might seem to be out of context, but it was a fashionable accessory in the 15th century. Use very dense, thick, and opaque paint applied with loose, gestural brushstrokes to paint these elements, making mixtures directly on the surface of the canvas that complement those previously made on the palette.

14. Begin painting the part of the turban that receives direct light, using lightened cobalt blue to which has been added a touch of sienna so it does not look so saturated. The brushstrokes should follow the direction of the gathered fabric. The video shows how to prepare the flesh tones and the blue for the turban.

15. The first blue brushstrokes are then complemented with others that create a tonal range, a progressive darkening or intensifying of the color from left to right. The dense layer of paint allows you to see the brush marks.

16. Add some dark areas to the turban with blue and a dab of raw umber. With the same color used for the background, define the shadows on the neck, its curvature and the edge of the back of the neck.

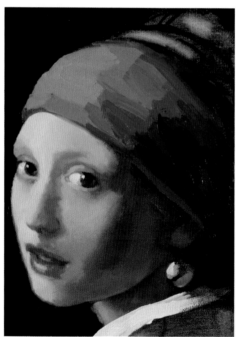

15

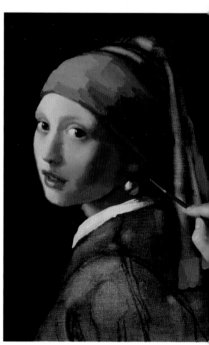

16

THE DETAIL OF THE PEARL

The pearl is one of the centers of attention in this painting; therefore, it is well worth enlarging. It is created with just two brushstrokes that reflect, on one side, the white neck of the model and, on the other, the highlights made by the same light source that illuminates the face from the side.

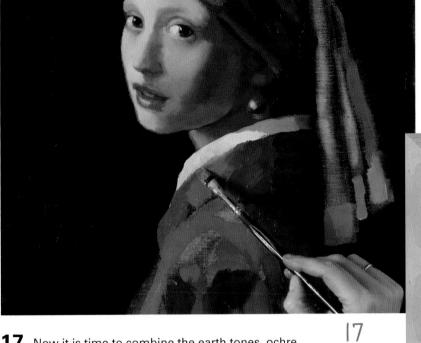

17

These colors will be more evident on the left half of the body, while the other, darker side is covered with gray and a grayish raw umber.

17. Now it is time to combine the earth tones, ochre, sienna, and raw umber, with each other and with a little white to outline the clothing.

18. The different earth tones on the coat are blended by simply going over them with a dry brush.

19. After the coat is sketched in, use the same colors, somewhat lightened, to finish the turban. Notice how the shaded areas look bluish; you can see that this color was used as a contrast to the ochre tendency of the folds.

19

18

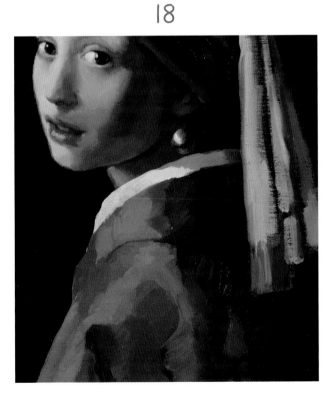

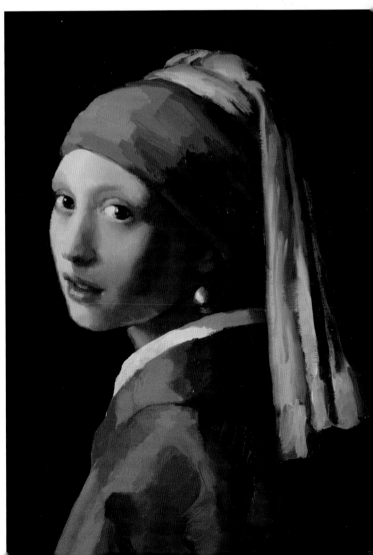

Time for Finishing

The key to Vermeer's paintings is based on the revelation of details, the secret life that is hidden in the small things and that can be perceived if the viewer studies the painting attentively. Therefore, you must be very careful with the small details, blending the surfaces with smooth modulations of light, and creating reflections and touches that can help illustrate the texture of the surfaces seen under an intense light source.

A SOFT BRUSH FOR BLENDING

The painter probably employed a badger or sable hairbrush, a sort of flat brush with soft hair that was used to delicately mix the illuminated tones of the skin with the darkest areas of the shadows.

20. The colors applied previously to the clothing are now blended. The brush technique is smooth but vigorous enough to capture all the shades of light in the irregularities of the clothing and turban.

21. Use your fingertip to smooth out some of the gradations that give the skin unity and continuity. There is no line that defines the edge on the left side of the girl's nose. It is marked by the color and tone of the cheek next to it. The lines on the right side of the nose and the nostrils are also lost in the shadows.

20
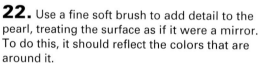

21

22. Use a fine soft brush to add detail to the pearl, treating the surface as if it were a mirror. To do this, it should reflect the colors that are around it.

23. The blue section of the turban is completed with additional details in the shadows that create the folds, alternating light tones with other darker ones. Finally, darken the space behind the model, the background, even more.

22

23
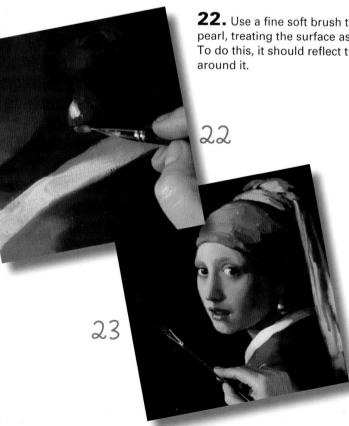

The finished work is a clear example of the capacity for observation and the artistic talent of the person who painted it, of his masterful ability to capture gestures. The expression of the girl is the essence of the painting; it is the great protagonist, complemented by the sensuality of the lips, and avoiding details that can distract our attention.

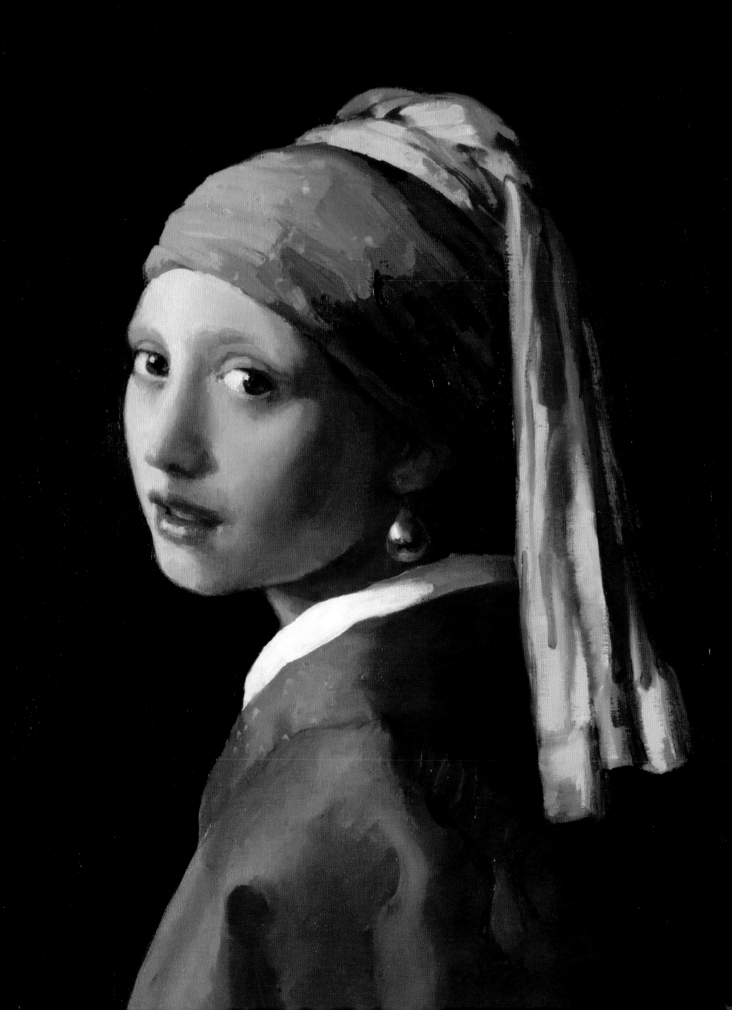

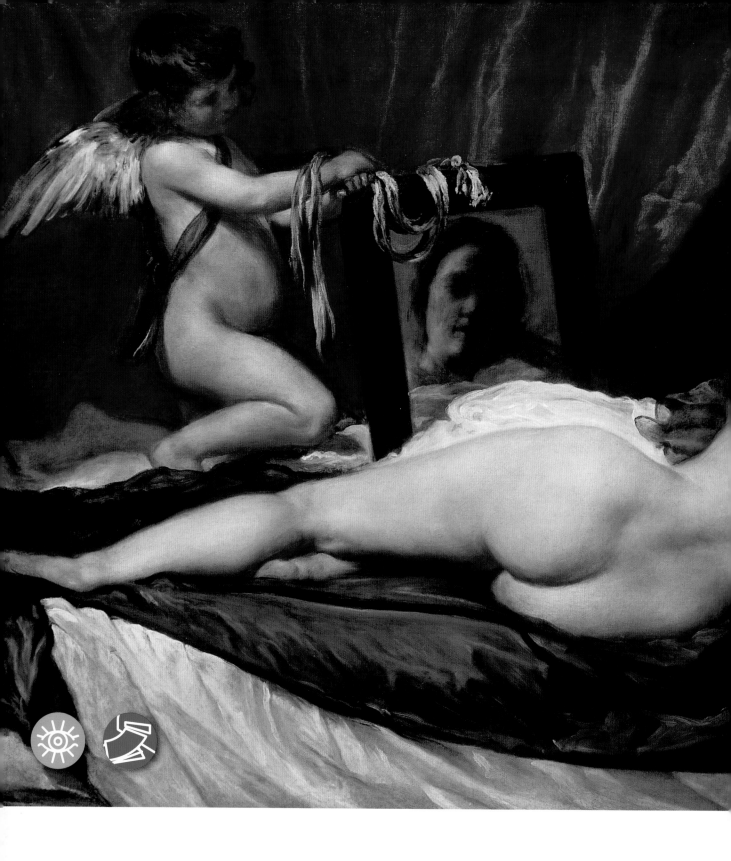

Venus at Her Mirror

Diego Velázquez, *Venus at Her Mirror*, 1647–1651. Oil on canvas, 48 × 70 inches (122 ×177 cm). National Gallery, London.

The next painting is the only feminine nude attributed to Velazquez, the most famous painter of the Spanish Golden Age. It is an erotic representation of the Roman goddess of love, beauty, and fertility, languidly and gracefully reclining on her bed, with her back to the viewer. Just in front of her is Cupid, holding a mirror that reflects her face. The most surprising thing about this painting is that the artist does not depict the body of the protagonist as a goddess (idealized and perfect) but as a worldly and typical woman of her era. The soft pink and crimson colors also stand out, and they will present the most difficulty in this lesson.

by **Velázquez**

Priming with English Red

During the time this painting was being restored (1965–1966), it was discovered that Velazquez had painted a layer of dark red, which he used as a background color, except in the area of the figure, which he left white. This approach gave the goddess a noticeably luminous presence and dictated the use of different base colors for her and for the drapery. The desire to emulate the great masters and their techniques means beginning this copy just as the artist did. Use English red directly from the tube.

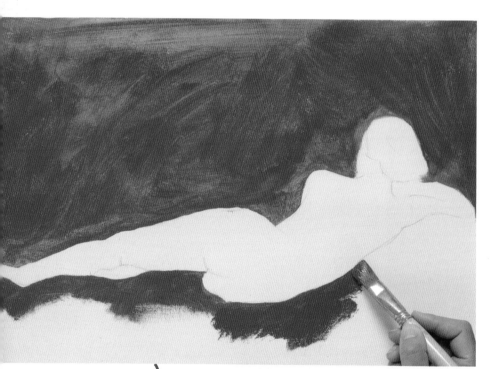

1. Use a graphite pencil to draw just the nude feminine figure. It is important to correctly indicate the space she is going to occupy with a very accurate outline. You can use a tracing from a photocopy of the original painting.

2. Using pure English red directly from the tube, cover the entire surface of the canvas except for the nude figure. This reddish earth tone will serve as a base for the glazes of color that will create the drapery in the background.

2

USING A RULER

In addition to being a necessary tool for drawing straight lines, the ruler can be used for comparing and transferring measurements on the canvas, which is important for creating a well-proportioned drawing.

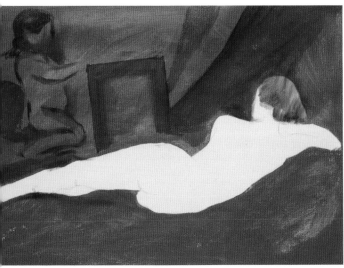

3

3. Let the reddish base coat dry for at least a couple of days. Then, on the palette, thin a small amount of burnt umber with oil painting medium to make the paint more fluid and translucent. Use this color to sketch in the curtain, the figure of Cupid, the mirror, and the hair of Venus, by applying light washes.

4. Darken the burnt umber paint with permanent violet. Continue overpainting with more brushstrokes to create glazing that further develops details in the body of the child, the chiaroscuro in the background, and the dark color that creates the base for the female figure.

4

5. Use a finer brush to apply the first strokes on the figure. Mark the curvature of the spinal column, the gluteus, and the outlines of the legs with light violet (a mixture of crimson, a touch of blue, and white).

5

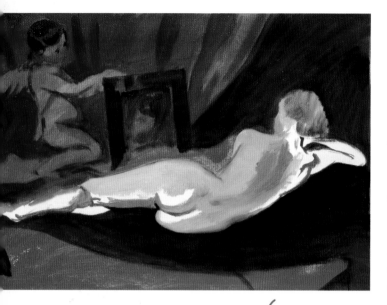

6

The Palette and Pigments of Velázquez

We know that Velazquez had a very restricted palette, and, but for a few exceptions, he used the same pigments throughout his artistic career. What changed was the way he mixed them and applied them. The pigments that he used in this painting were lead white (we will substitute titanium white), earth red from Seville (which would be today's English red), burnt sienna, yellow ochre, dark crimson (contemporary alizarin crimson), brown (burnt umber), ivory black, and blue (probably Prussian blue). He also likely used a raw umber as well, made from iron oxide and manganese.

6. To make the pink flesh tone, mix alizarin crimson with a lot of white. If you wish, you can also add a touch of Prussian blue so the tone will look a little more violet on her back. Blend this application with the previous brushstrokes.

7. Use a mixture of alizarin crimson and a touch of Prussian blue to paint the lower sides of the legs. The bluish brushstrokes should be mixed with the pink flesh tone.

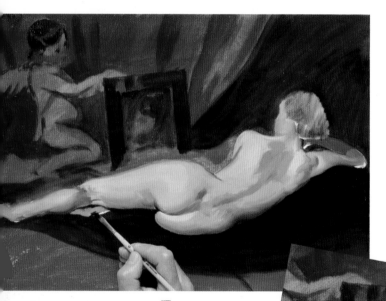

7

8. The body of the Venus should be painted with rich and opaque pink tones. The luminescent colors of the skin, caused by the presence of white in each mixture, should be applied with a smooth, creamy treatment, with blended brushstrokes, modeling the voluptuous relief of the figure.

8

HOW TO CREATE THE SKIN TONE

The flesh tones of Venus are made by mixing, in unequal portions, dark alizarin crimson, titanium white, burnt sienna, and a dab of Prussian blue.

9

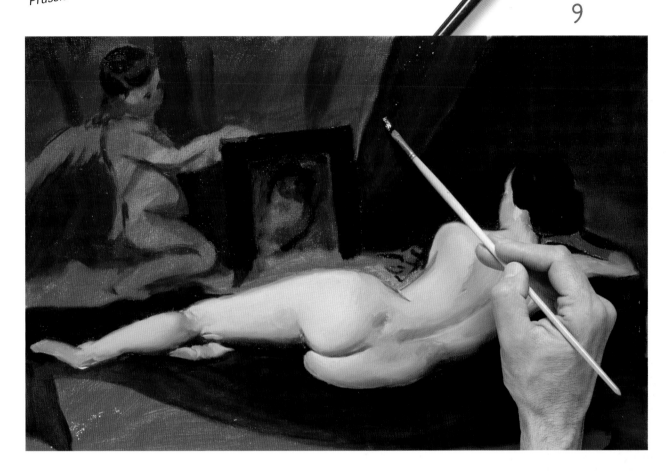

9. The figure seems even more luminous when you darken the background that surrounds her with a glaze of burnt umber sprinkled with some touches of violet and gray. Use this newly added paint to finally indicate the outline of the figure, while correcting any possible errors.

10. To finish the figure of Cupid use the same mixture of colors you used for the goddess, and use the *alla prima* technique, which consists of blending and modeling the range of pinks directly on the canvas. The color of the shaded areas was made by combining pink with burnt sienna. The video shows how to create the reflection of Venus's face in the mirror.

10

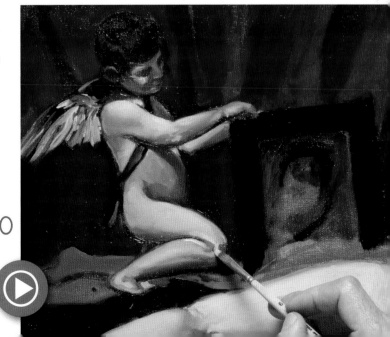

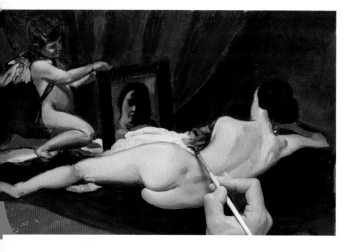

11

Drapery

Although the drapery in the background was painted, until this point, with thin glazes of dark color over a monochrome base coat of English red, in this final phase the fabric will be finished with an addition of thicker paint that will allow you to model the folds and wrinkles somewhat easily and to emphasize the way the light falls on them. The folds of the sheets on the bed repeat the physical form of the goddess and form arabesques that reinforce the pronounced curves of her figure.

11. Mix a dark gray with burnt umber and Prussian blue to paint the frame of the mirror and sketch the face in the reflection. Use this same gray lightened with a lot of white to paint the sheet, focusing on the folds and the shadows, which should be indicated by making long curved strokes with the brush.

12. The relief of the fabric can be resolved *alla prima.* First, spread a layer of dark gray or white (depending on the color of the fabric), and then create the folds with new colors applied over the wet paint so that they blend and look like highlights. Watch the video to see how to construct the folds in the fabric.

12

The sheets and the curtains, so carefully treated with chiaroscuro effects, were made with a specific intention: Cupid, the mirror, the diagonal curtain, and the wall in the background, all give the impression of being in a very deep space. On the other hand, the carefully painted folds of the drapery add movement and dynamism to a static pose. Notice that in the most translucent layers on the upper part of the painting the quantity of oil painting medium was increased until the paint almost turned completely liquid.

13

13. It is a good idea to avoid making the painted brushstrokes that look very hard and frayed. These contrasts can be smoothed by lightly caressing the fresh paint with a fan brush.

Velázquez was capable of creating a masterwork of many varied colors, with just five or six pigments.

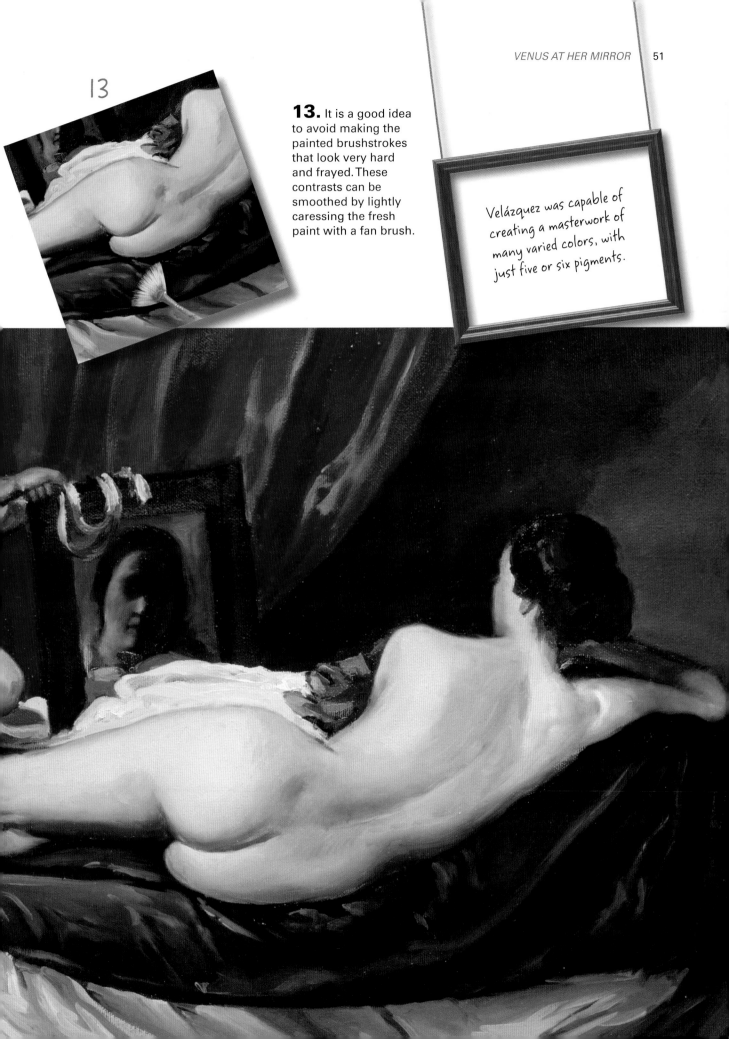

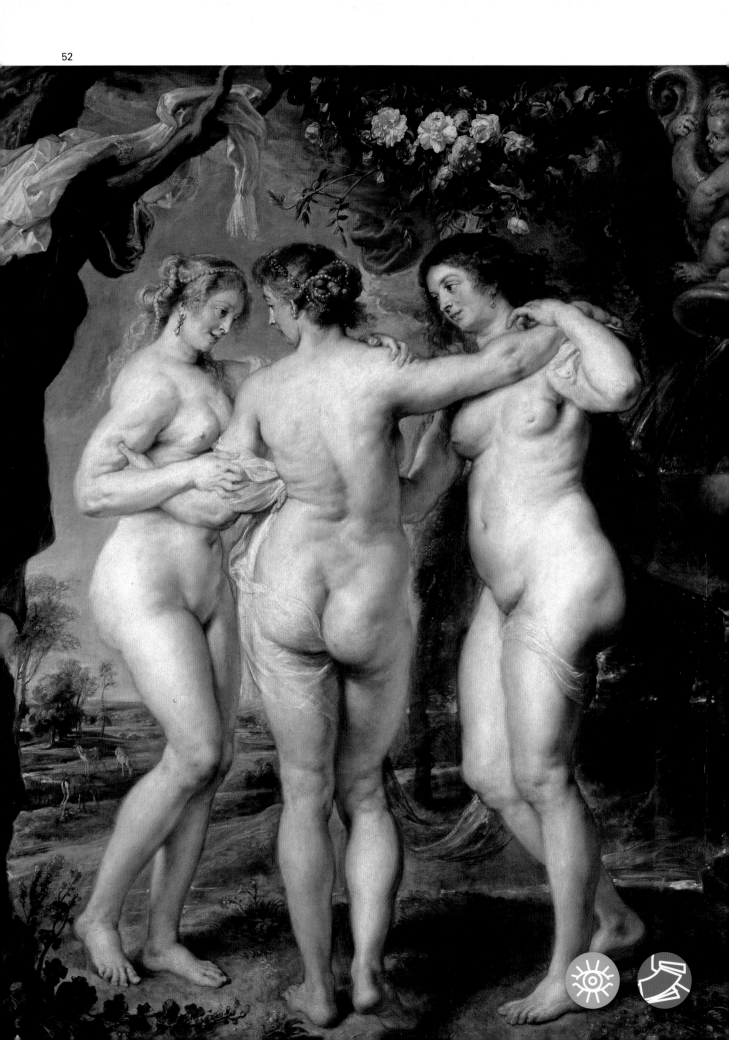

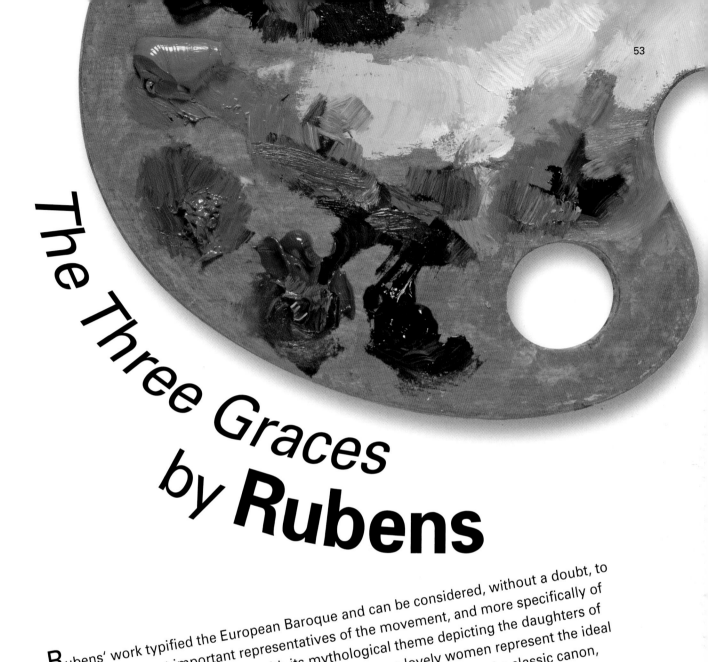

The Three Graces
by **Rubens**

Rubens' work typified the European Baroque and can be considered, without a doubt, to be one of the most important representatives of the movement, and more specifically of the Dutch School. This painting, with its mythological theme depicting the daughters of Zeus, is one of his most famous creations. These three lovely women represent the ideal of beauty in the Dutch Baroque period, which is quite different from the classic canon, and it is characterized in the representation of rather heavy women that are still well proportioned, and even elegant, with ample outlines and generous curves. Perhaps the most outstanding aspect of the painting is the treatment of the flesh tones, which seem to radiate light on the rest of the scene. In this sense, it is helpful to remember that Rubens was a fervent defender of the use of light as opposed to the Tenebrism popular in the Baroque era. Therefore, the basic thing that you should keep in mind while making your copy is to use dazzling, radiant light on the skin tones, applied with free and expressive brushstrokes that are very carefully modeled.

Peter Paul Rubens, *The Three Graces*, 1630–1635. Oil on canvas, 87 × 71 inches (221 ×181 cm). Prado Museum, Madrid.

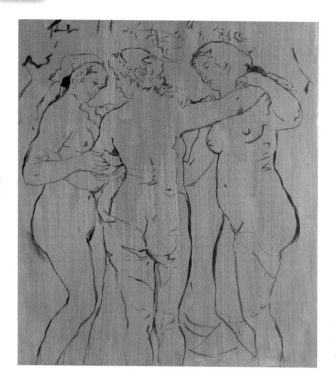

A Brown Color Background

Upon studying the underpainting in Rubens' original works, you will see that his paintings begin with a gentle monochrome harmony, which he composed using underpainting that consisted of medium gray or yellow brown that completely covered the canvas. The latter was certainly made with an earth tone that was agglutinated with an oil drier. It is on a base coat of this color that we will build up the flesh tones with gradations and modeling. This will create a harmonious effect in the painting with a yellow tendency; furthermore, by adding light and dark tones from the beginning the figure will very quickly become three-dimensional. Copies of paintings do not have to use the same framing as the original. In this case, the copyist chose to crop the framing to focus the attention on the anatomy of the figures.

1. The silver ochre background will have to be accepted as a simplification of the underpainting; it is made by mixing yellow ochre with raw umber to create a medium tone. The image of the painting was projected on the canvas so that the charcoal drawing would be as accurate as possible.

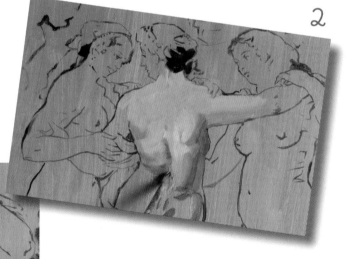

2

3

2. The charcoal lines should be sprayed with a fixative so they do not muddy the light colors of the flesh tones that will be painted over them. Since you are working on a medium tone background, you can begin by painting the intense light on the back of the figure with very light ochre and burnt umber.

3. At this point, you can appreciate the use of the brown in the background and how it affects the tones and gradations that are added. Notice how the figure emerges with applications of light and thin layers of colors mixed with white. The ochre in the background can still be seen as a light outline of the flesh tones, harmoniously blending with the more pink and gray tones.

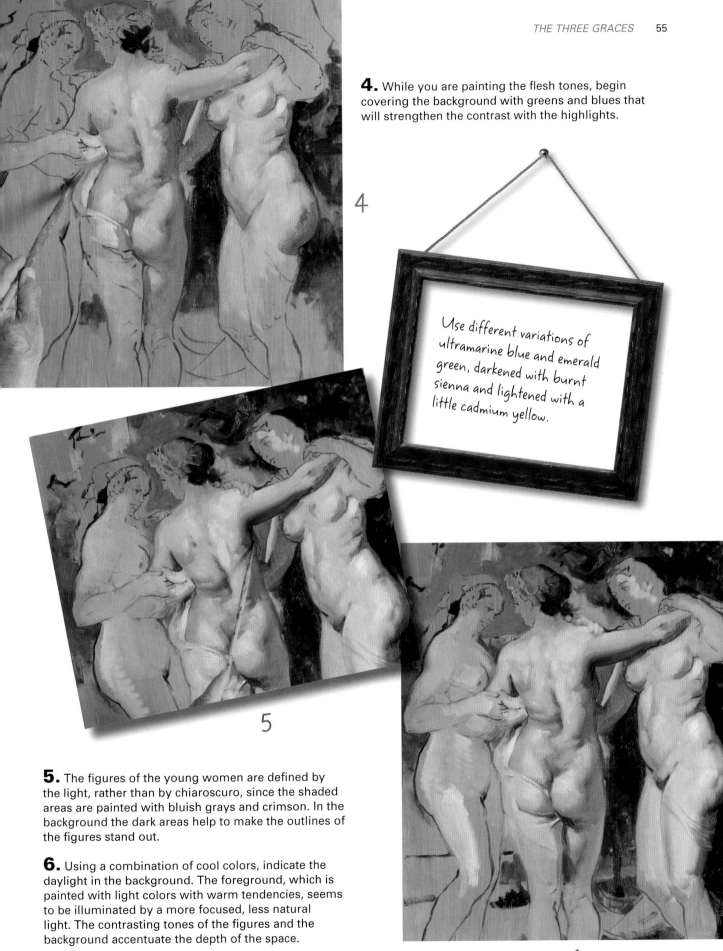

4. While you are painting the flesh tones, begin covering the background with greens and blues that will strengthen the contrast with the highlights.

4

Use different variations of ultramarine blue and emerald green, darkened with burnt sienna and lightened with a little cadmium yellow.

5

5. The figures of the young women are defined by the light, rather than by chiaroscuro, since the shaded areas are painted with bluish grays and crimson. In the background the dark areas help to make the outlines of the figures stand out.

6. Using a combination of cool colors, indicate the daylight in the background. The foreground, which is painted with light colors with warm tendencies, seems to be illuminated by a more focused, less natural light. The contrasting tones of the figures and the background accentuate the depth of the space.

6

The Pigments Used by Rubens

The colors used by Rubens are arranged into three groups here: lead white (since this no longer exists, we are using Titian white), natural gold pigment, yellow ochre, yellow lacquer, carmine lake (real alizarin crimson), vermilion (cinnabar or sulfur of mercury), pink ochre (this is light red, an oxidized yellow ochre), ultramarine blue, German blue (today's Prussian blue), copper hydroxide, earth green (Verona green earth), green malachite (today's emerald green), verdigris (copper hydroxide acetate, which is obtained from copper in vinegar vapor that form what is called moss green), burnt sienna, and ivory black.

Rubens advised against mixing more than two pigments on the palette and opted to apply the paint directly and separately on the canvas and mix them there with the tip of his brush.

7

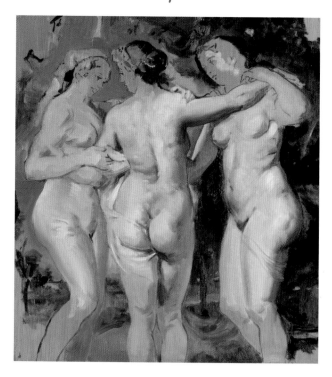

7. The various parts of the anatomy are then indicated using a light gray, pink, or burnt umber color, depending on the area and intensity of the shadow. The flesh shows pearly reflections that are most visible on the most prominent parts of the back and buttocks.

8. In contrast to the dark vegetation in the background, the volume of the figures is developed by modeling, the brown, pink, and whitish tones are blended with a brush, and the strokes are repeated to create smooth transitions in the form of gradations.

8

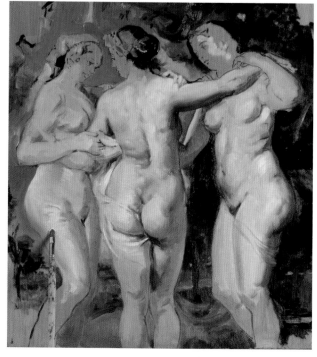

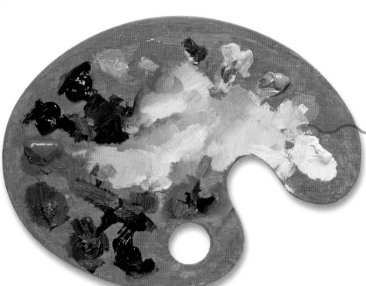

UPDATING THE COLORS

This is the palette used by the artist who painted this copy where the paints used by Rubens were adapted to more modern ones, for example, a mixed green instead of Verona green earth, or alizarin crimson instead of carmine lake.

WORKING WITH PRECISION

Two pieces of wood were added to the back of this board so it can be used as a brace to keep you from resting your hand on the fresh paint. It can be very useful for precise and detailed work.

9

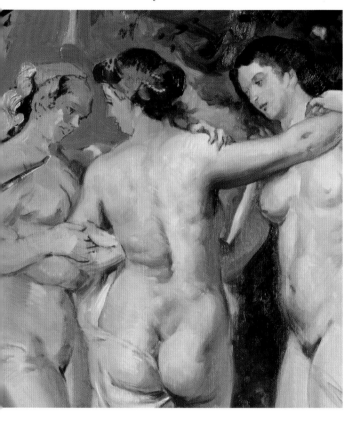

9. As you work on the faces, keep changing the brushes for finer ones so you can apply smaller amounts of color and make more precise brushstrokes. To the hair add brown darkened with Prussian blue, painting directly and with curved strokes following the direction of the hair.

10. Until now, the color of the flesh tones were very light mixtures tending toward pink, but from now on you should apply warmer touches with yellow ochre that can be seen on the face of the figure at the left. This color should also be echoed on the other two figures. The video shows how the artist builds up the flesh tones on the woman's arm.

11. Add the final touches to "invigorate" the highlights, but with a modulated color, not pure white. This will separate the figures even more from the background. Treat the texture and adornments in the hair with greater detail, emphasizing the most illuminated areas with ochre or cadmium yellow.

11

10

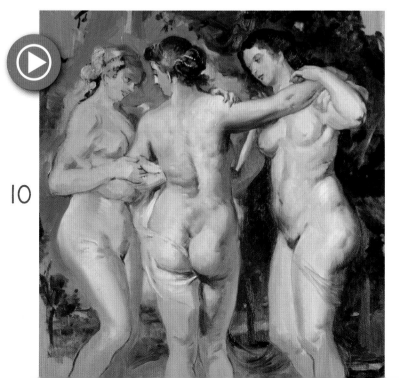

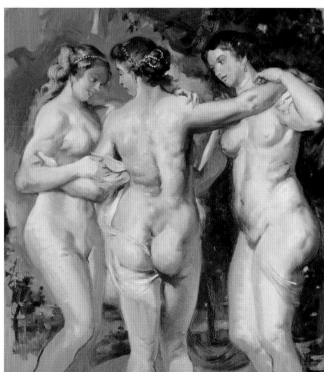

Smoothing and Glazing

Finally, the colors on the flesh should be blended so they will communicate the soft and velvety feeling of the skin, which is done by smoothing the still fresh paint with a soft brush. You should also apply final glazes on isolated fragments, ochres and pinks over some areas of the flesh tones, and ochres and yellows on the dark vegetation in the background. These applications can be made more fluid by adding a little oil painting medium so the colors will be less striking. We know that Rubens lightly added warm shading over the whitest highlights on the shadowed volumes, using barely perceptible glazes.

12

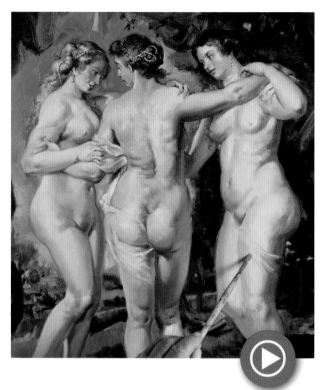

13

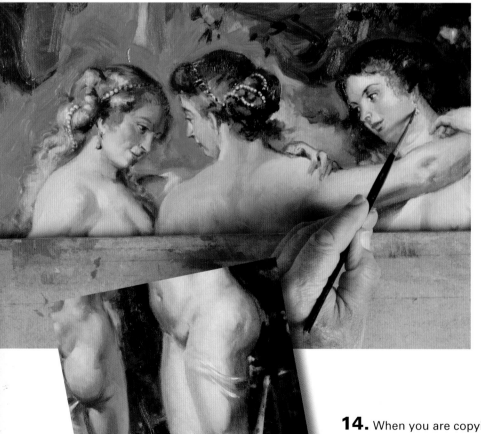

14

12. You must wait a few days for the surface of the paint to dry completely before painting the fine drapery of transparent fabric on the figures, using glazes to resolve them. When the time has come, mix titanium white with oil painting medium to make a translucent wash that will work very well for this purpose. The video shows you how to construct the transparent fabric.

13. The faces are the most delicate parts of the painting and require a steady hand and precision with a very fine brush. Here the artist uses the previously described board to comfortably rest his hand to avoid any faltering and trembling that is typical when a support is not used.

14. When you are copying, there is a certain margin for interpretation, it does not have to be photographic. In this case, the background of the painting has been left a bit less defined than is normal, and the details have been loosely finished with small well-executed dabs of color.

The work can be considered finished after you resolve the most important details of the faces, the hands, and the decorative elements of the hair and the garlands of flowers in the upper area. Darken the ultramarine blue of the sky; this is important to silhouette the outlines of the heads of the figures.

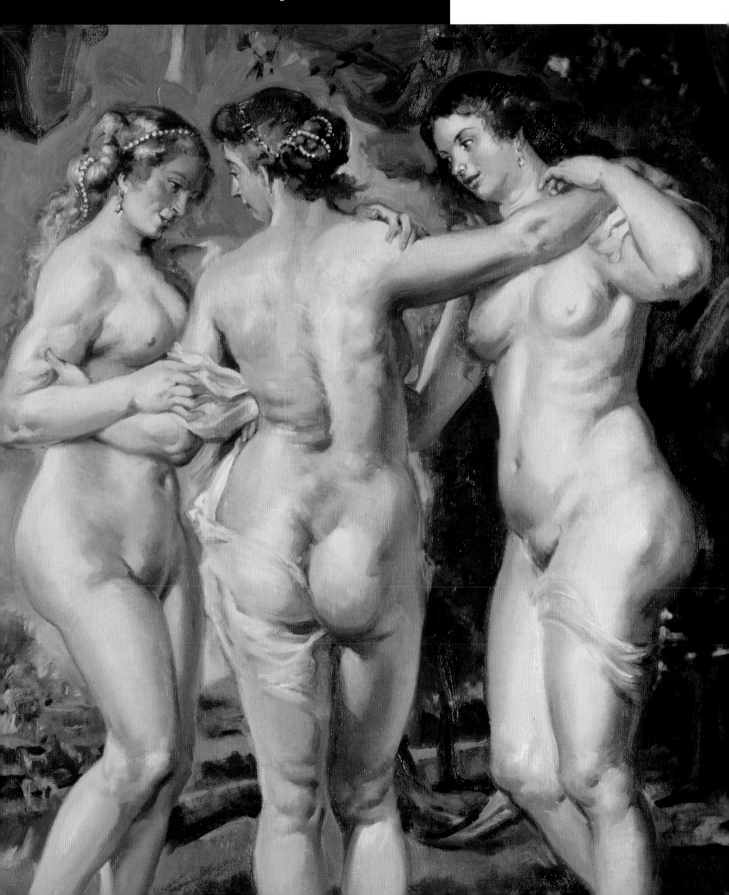

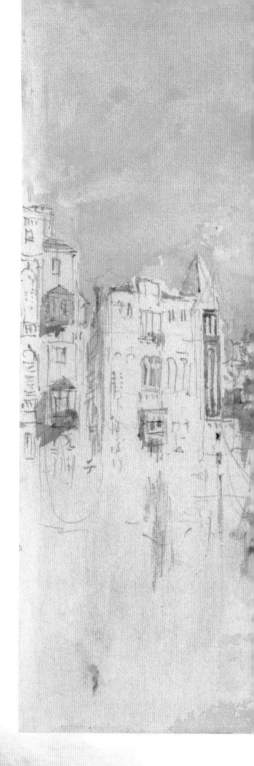

William Turner is considered to be one of the best British watercolorists of all time, and he is without a doubt one of the artists who did the most to develop and increase interest in watercolors. The following model is an urban landscape in Venice, the romantic City of Canals, outstanding in its monumentality and the beauty and antiquity of its buildings. Turner's work is not characterized by its likeness of the original model, but for the opposite. In his paintings, you can see a destructive transmutation that takes the forms to the edge of dissolution, where he deforms, alters, and disintegrates the façades and silhouettes of the Venetian palaces in a sort of material light, or an ethereal fog.

Joseph M. William Turner, *Venice: The Grand Canal, from Near the Accademia, with Santa Maria della Salute in the Distance*, 1840. Watercolor and pencil, 43.5 × 58.25 inches (110.5 × 148 cm). Tate Gallery, London.

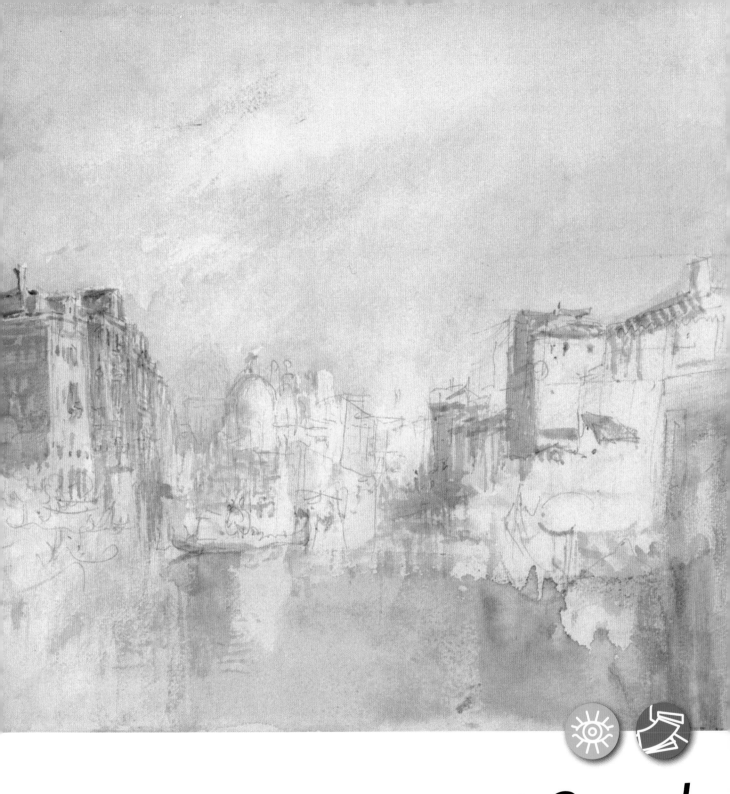

Venice: The Grand Canal
by Turner

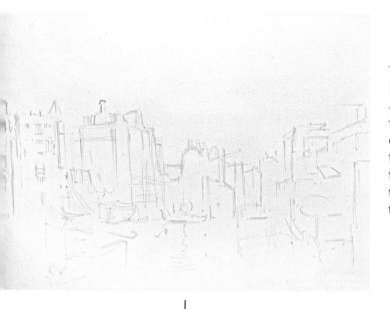

Light and Atmosphere

Turner's watercolors are characterized by their perfect balance of luminosity and chrome. The artist had the ability to blend two nearly opposite painting traditions: the mastering of light and shadow and the use of color. In his paintings, the brightest colors, applied in thin glazes, have a rare purity and light. He used the techniques of *summate* and mixing watercolors in wet to successfully express the light and atmosphere of the scene.

1. Make the sketch with an HB graphite pencil. Try to draw the approximate shapes of the buildings following the style and amount of definition that Turner would give them.

2. To create the atmospheric sky, first dampen the paper with a wide brush soaked with water. Any application of color on the wet paper will look blurry. Watch the technique for painting the sky on wet in the video.

3. The colors of the sky are made by applying strokes of cobalt blue, Payne's gray, yellow ochre, and a touch of sienna. Then paint the reflection on the water of the canal with a mixture of cyan blue and yellow ochre.

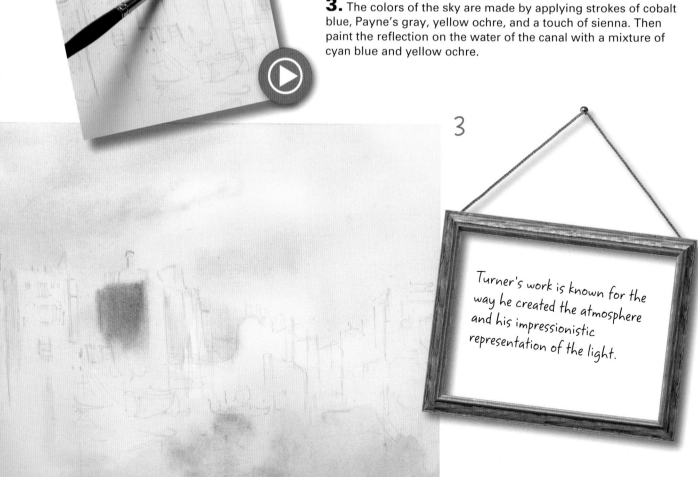

Turner's work is known for the way he created the atmosphere and his impressionistic representation of the light.

4

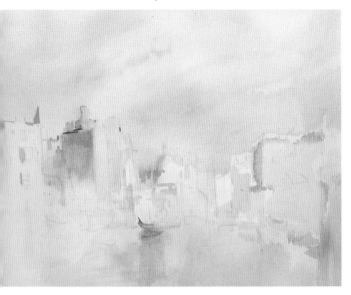

4. In this first state, we have spread a first layer of diluted paint where the colors have mixed with each other. The overall presence of a color that is closely related to Romanticism, like yellow or very light yellow ochre, creates an "impressive" quality, which is ideal for painting with Turner's light.

5. The work of constructing the façades is very meticulous, and it must be done with a fine round brush. Cover the first layer with washes of earth tones (mainly ochre and sienna) to make the details of the buildings stand out. The wash should be diluted and not contrast very much.

5

6

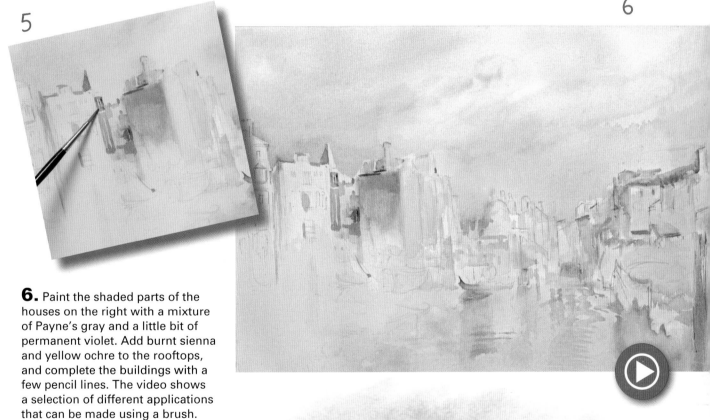

6. Paint the shaded parts of the houses on the right with a mixture of Payne's gray and a little bit of permanent violet. Add burnt sienna and yellow ochre to the rooftops, and complete the buildings with a few pencil lines. The video shows a selection of different applications that can be made using a brush.

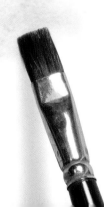

BLURRING

When brushstrokes of paint are applied to a wet surface the pigment runs and creates a blurred effect.

The Art of the Unfinished

This painted study, which might even be considered unfinished, looks like one of the recurring subjects of Turner's watercolors. In his urban views, the buildings become taller, the walls are hazy, and the forms dissolve into images of pure light and color that are in perfect harmony and create evanescent, blurry, and evocative atmospheres. There is no room for details in a work made of light washes of color that do not hide the pencil lines.

7. Use areas of flat translucent color to progressively complete the puzzle of superimposed façades and rooftops. The windows and balconies are barely indicated with very pale violet shadows. There is minimal contrast, which is achieved by diluting the paint with a large amount of water.

8. The façades that are bathed in sunlight are left in the original light ochre wash, while the rest become more solid through the application of washes that progressively build up the color. The water should also be darkened with a new wash that better defines the banks and the reflections.

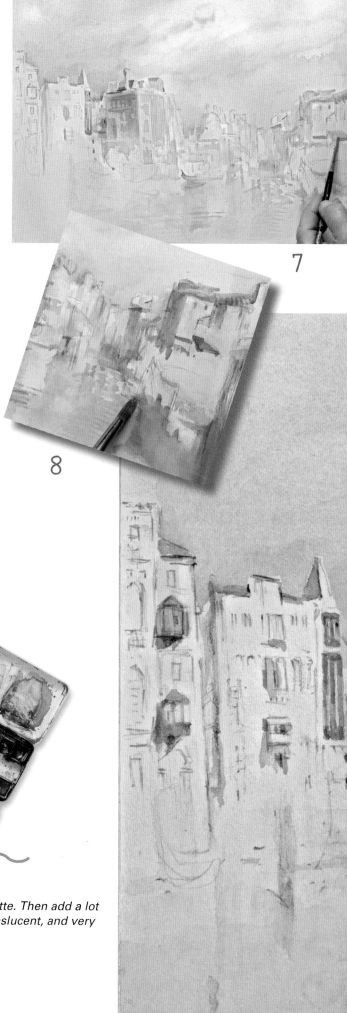

7

8

TRANSLUCENT BRUSHSTROKES

Mix the paint until you get the correct color on your palette. Then add a lot of water so the brushstroke will be faint, full of light, translucent, and very similar to the work of Turner.

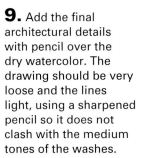

9. Add the final architectural details with pencil over the dry watercolor. The drawing should be very loose and the lines light, using a sharpened pencil so it does not clash with the medium tones of the washes.

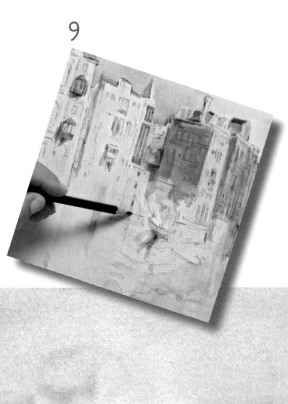

The gondolas are barely suggested with a couple of well-applied strokes. Notice the unfinished look of the left half of the painting and the sketched treatment of the buildings, especially those that seem farther away. In short, a painting that is loose and yet accurate that is not at all inferior to the original.

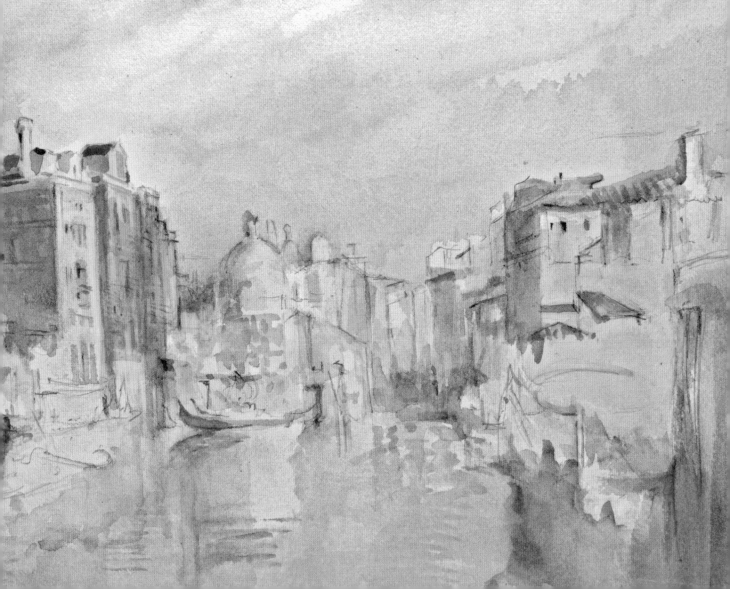

Wanderer Above the Sea of Fog

by Friedrich

Caspar David Friedrich was one of the most important artists of the German Romantic movement. He always showed great interest in the study of nature, which he captured in many sketches that he used to create very beautiful, magnificent, and grandiose natural scenes in which he constructed an endless space that overwhelms the senses. This work is a good example. In the center, a hiker has paused on a rocky crag at the edge of a precipice. He has turned his back toward the viewer, observing a sea of clouds that flow over some nearby mountains. The image evokes the silence that reigns in the peaks, barely altered by the breeze that is blowing in the hair of the wanderer. This exercise, which will be done in oils, requires a very realistic treatment and attention to detail.

[39] Caspar David Friedrich. *Wanderer Above the Sea of Fog*, 1818. Oil on canvas, 38.75 × 29.5 inches (98.4 × 74.8 cm). Kunsthalle Hamburg, Germany.

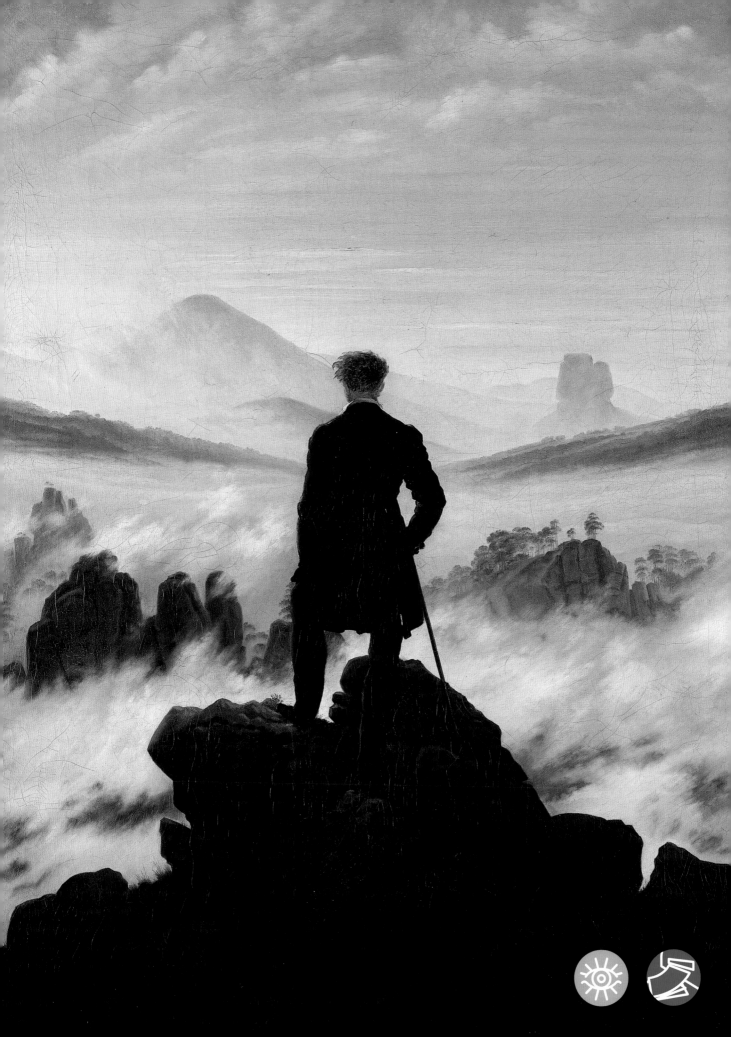

1

A Spiritual Painter

Friedrich organized his work based on sketches collected during many years of treks, sketches that he later included in his paintings, without a worry about how many years had passed since they were made.

However, when the artist decided to paint this picture, he did not simply copy a sketch; on the contrary, before making a single mark, he first stood for a long time in front of the canvas trying to visualize in his mind the image of the landscape that he wanted to paint. He waited for this to surface from the inside so that he could create a more "spiritual" vision of the model. We, as simple copyists, will limit ourselves to blocking in the drawing with charcoal. First we will fold up the reproduction that we are using as a model so we can maintain its proportions.

2

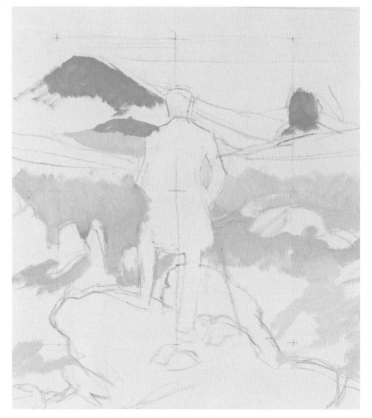

1. The reproduction that you use should be large so that you can easily see the details in the painting. Fold it evenly to create a grid so it will not be necessary to draw lines on it with a marker.

2. There is no need to draw a grid on the canvas; you can just make small crosses at the places where the folds intersect. This will be enough to use as a reference for you to lay out all the elements on the plane of the painting.

3

3. The drawing, which is quite symmetrical, should be made with charcoal. Before painting, fix the pigment with a spray fixative and then apply the first brushstrokes of diluted oils, using very light, grayish neutral colors.

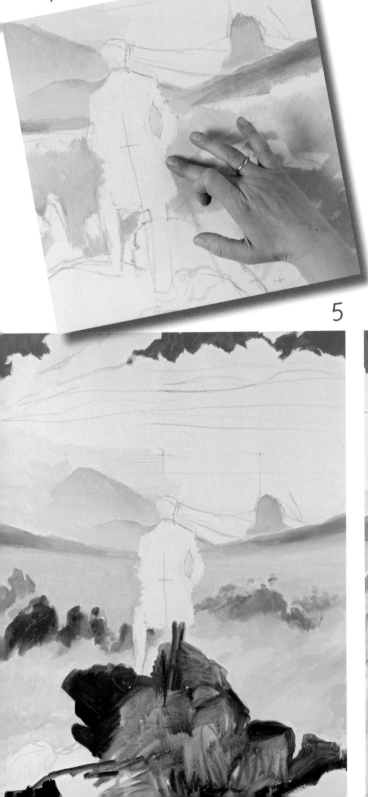

4

TONAL BASE

The incorporation of the very light, grayish colors is meant to achieve a preliminary general tone of the light in the landscape before adding the contrasts and the figure that appears as a silhouette.

4. Create the effect of the fog by blending the first applications with the fingertips, which will cause blurring or blending among the very similar grays.

5. Sketch in the foreground with very diluted paint, without worrying about the details. The colors are grayed, and could even be considered muddy. Blend them and mix them with each other, and even allow them to drip.

6. Now add a thicker layer of paint over the first diluted applications, and allow the marks of the quick brushstrokes to show. On the rocks, use a mixture of grays with tendencies toward blue, green, violet, crimson, ochre, and sienna. Use these colors to construct the figure.

5

6

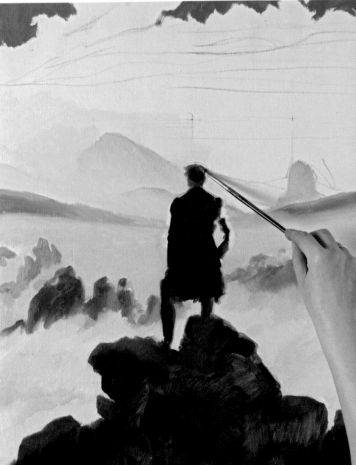

Creating the Illusion of Depth

The horizon barely exists in this painting. The space is limitless; it creates a sense of something sublime and eternal that cannot be explained with words, but only feeling. The effects of light and the clouds create a more suggestive feeling, which can be strengthened by blending very light colors and a jump in tone that allows you to depict the mountains as if they were a theatrical backdrop. The person in the foreground in silhouette is also very important in increasing the illusion of depth.

7. The mixtures made on the palette for finishing the sky and the fog are very, very light. Cover the background with different variations of white tinted with yellow, blue, gray, and brown. The distant mountains should be constructed with a light gradation. Watch how the colors are blended on the video.

8. The thick, creamy layer of paint can be modified and blended and the tones gradated to form the dense vague mass at the base of the rocks in the promontory, painted with lightened raw umber. You can see this done in the video.

9. Darken the figure with a mixture of ivory black and burnt sienna. Mix them in unequal amounts to represent subtle changes in tone. Keep the underlying blue gray around him.

> The rocks are constructed with gradated tones of brown and gray and shaded with a touch of blue and violet.

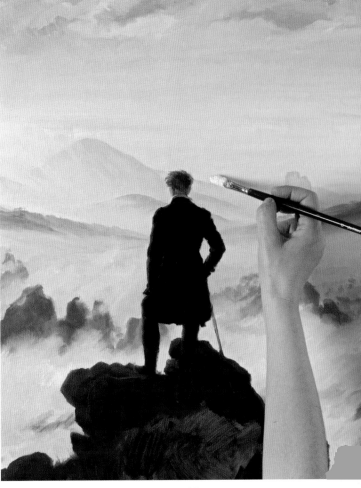

II

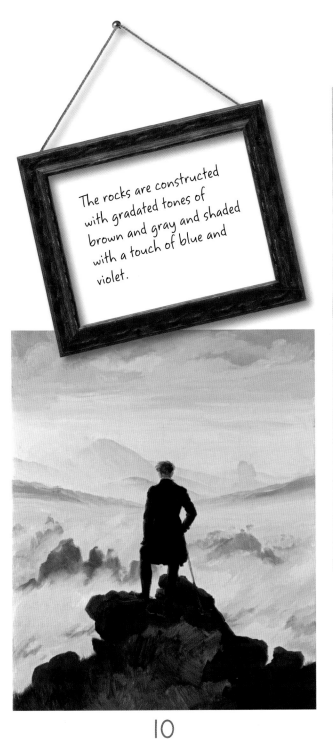

10

10. Apply layers of more opaque paint over the base of diluted colors to define the promontory where the figure is standing. The outline should be well defined, clearly separated from the white fog.

11. Add some coloration to the upper part of the sky, a more yellow orange tinged white. While the paint is still wet repeatedly apply long horizontal brushstrokes of Naples yellow red mixed with white, so that each new addition of color blends with the underlying ones.

THE SKY AND FOG

Gradating and blending oil colors is important in creating the bases of the sea of fog and of the coloration in the sky. The blending will be done with a brush.

12

The Foreground in Silhouette

Despite being clearly silhouetted in the foreground, in deep shadow, the variety and richness of colors on the figure is surprising. This shows that Friedrich did not take the easy approach of excessively darkening his colors, so we can clearly distinguish the chromatic differences within the areas of shadow. He only used black to neutralize colors and unify them within the range of grays. In its pure state, he used it only in specific cases, in some shadows and to define the wanderer's suit.

12. To paint the darkest areas of the rocky place in the foreground, add a touch of black to raw umber, to emerald green, to cobalt blue, and to burnt sienna on the palette. The result will be a scale of dark neutral colors that can be used to differentiate the planes of each rock.

13. The final touches are made with ivory black in its purest state. Use it to paint the bottom of the pants, the walking stick, and the shadow projected by the figure, the last should be slightly shaded with still wet grays and browns.

THE COLORS OF THE ROCKS

Do not overuse the black. By just adding a touch to each mixture, you can create an ideal range of grays for darkening the foreground.

13

Finish a few details: adjust the shape of the clouds in the upper part of the painting and sketch in the vegetation on the peaks in the middle ground, with just a few bluish glazes. The finished work is a romantic vision of the solitude and insignificance of the individual when facing the power of a splendid and overwhelming nature.

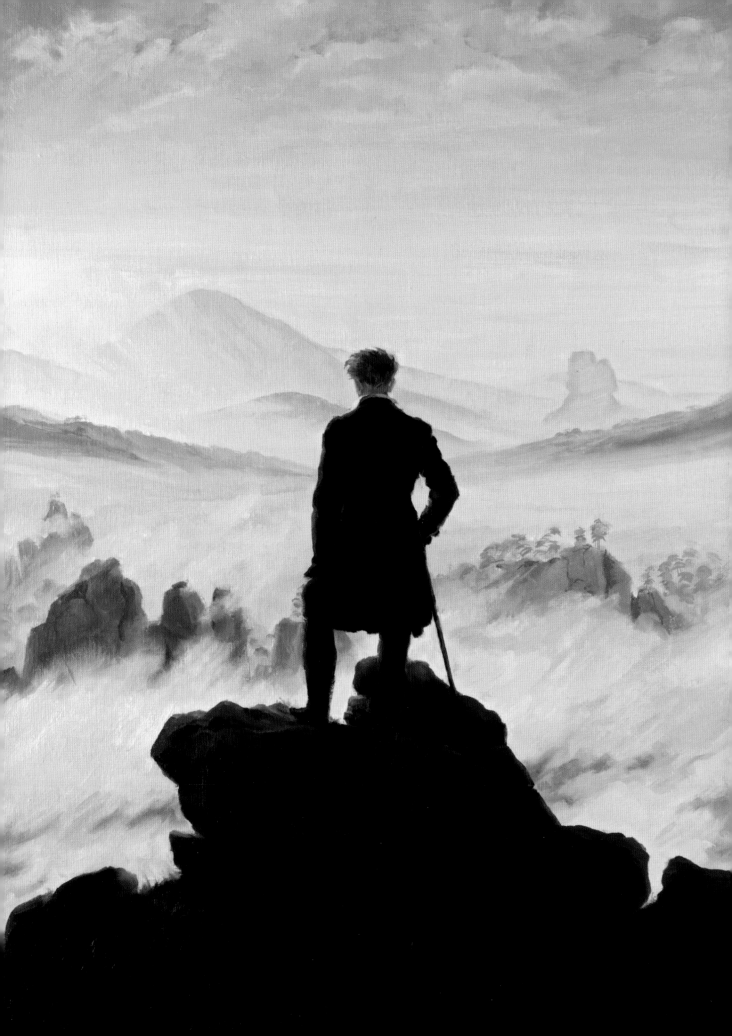

The exercise we will do here consists of reproducing the painting *Woman with a Parasol*, painted by Claude Monet (1840–1926).

The light, the brushstrokes, and the colors make this work an exceptional example of Impressionism, and the woman is one of the most enigmatic and enchanting figures painted by this artist. The figure is seen from below, that is, from a low point of view. She is located on a hill where the wind blows and the intense sunlight creates a dramatic backlit effect. The interesting part of this painting will be in recreating the look of the artist, who applied quick layers of color with elegant brushstrokes that seem to be lengthened by the effect of the wind that agitates the grass and clouds.

Woman with a Parasol

by Monet

Claude Monet, *Woman with a Parasol*, 1886.
Oil on canvas, 35 × 51.5 inches (88.7 × 131 cm).
Musée d'Orsay, Paris.

Blocking in the Drawing with a Grid

The grid is used to divide the model and the painting into regular shapes to help you make the initial drawing, making sure that all the parts of the copy maintain the correct proportions. Copying with a grid helps you interpret the direction and angle of each one of the lines that define the outlines of the shapes and to locate the drawing on the support. However, even though the possibility of error is greatly reduced, using a grid is not as precise as a tracing.

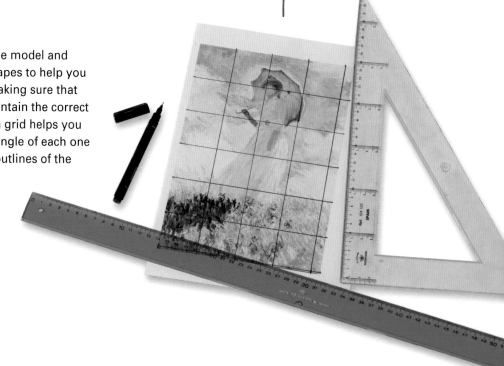

1. Draw a grid of regular squares on a printed image of the painting. We recommend using a ruler and triangle to make sure that the grid is perfectly square.

2. Repeat the same grid on the surface of the canvas. Here the squares will be larger, but you must draw the same number of squares that you made on the printed image.

3. To lay out the drawing, you must focus on the individual squares, one at a time, and reproduce the shapes that are inside them. Little by little, the pieces will begin to fit together just like a puzzle.

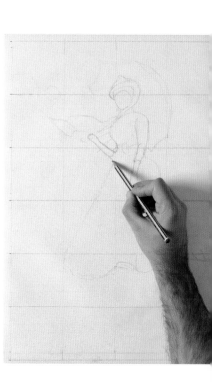

REDUCING THE OIL IN THE PAINT

The Impressionists discovered that thick paint, with very little oil, was better for imitating the effects of light in nature. For this reason, they absorbed some of the oil in the paints before using them. They did this by putting the paint on blotter paper for a few minutes and then returning it to the palette with a spatula.

4. The first drawing should be very light, while you work on locating the shapes in each square. Go back over the outline of the main figure a second time to make it more visible.

5. First, cover the sky. Use undiluted, thick, dense, dry paint, and apply grayish strokes on several areas at the same time. Do not worry about the drawing in the grid, because it will disappear under the layer of oil paint.

4

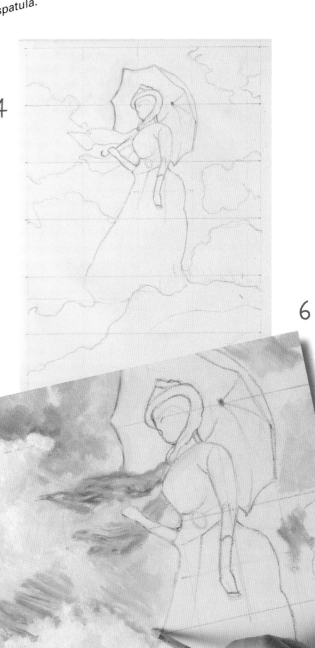

5

6

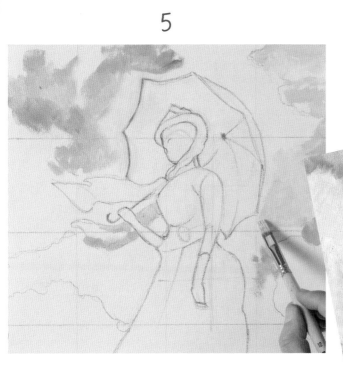

6. The gray is made by mixing an orange color with ultramarine blue. Neither earth tones nor black belong on this palette. When building up the clouds, the grays should be blended and gradated with a yellowish white or a very light blue, depending on the case. The video shows the process of painting the sky.

7

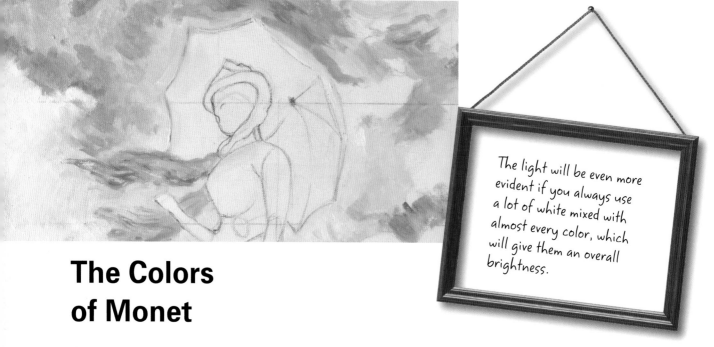

The light will be even more evident if you always use a lot of white mixed with almost every color, which will give them an overall brightness.

The Colors of Monet

When painting this scene, Monet used a palette of luminous colors where titanium white and ultramarine blue dominated. To these he added cadmium yellow, a very stable color, and cobalt violet. The latter, which became available in 1859, was the first opaque violet that appeared on the market, and it was immediately adapted by the artists of the era.

Vermilion was also on his palette, one of the few traditional colors employed by Monet. He used it almost straight from the tube for flowers, and it appears all over mixed with other colors. The greens were painted with emerald. He did not use earth tones; he made his dark colors by mixing complementary colors, red and green for example, since they created more interesting colors than those mixed with black. This is what you will do here.

7. Monet used the properties of the commercially primed white canvas to paint the sky, and he gradually abandoned the brown color that he had been using as a preliminary layer.

8. The brushstrokes of yellowish white seen between the white of the clouds and the blue of the sky create an optical effect similar to sunshine. The cream color is emphasized by the adjacent blue, which at the same time seems cooler. In nature, the warm yellow light finds its contrast in the luminous violet blue reflected in the shadows.

8

COLORS OF THE SKY

The palette we will use for painting the sky is the same one that the artist used. It was quite limited: titanium white, ultramarine blue, cadmium yellow, Naples yellow, and violet. Black was abolished, so the grays were made by mixing yellow, violet, and a bit of white.

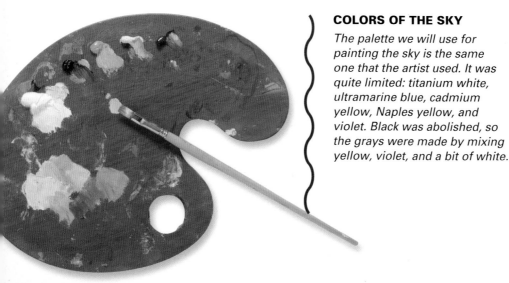

9

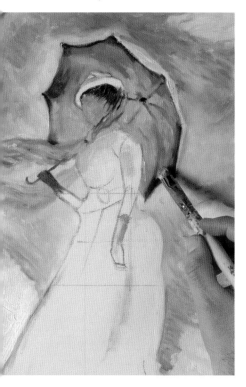

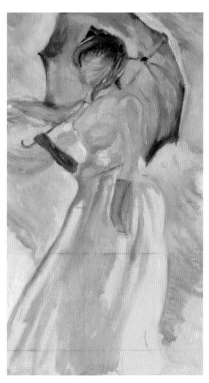

10

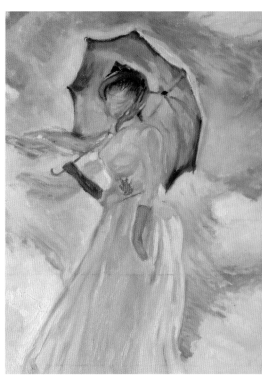

11

9. Next, approach the figure with colors that are somewhat darker because of the difference between the light in the center of the painting (the figure) and the area around it (the sky and vegetation). Shade the emerald green with Naples yellow and a bit of violet to complete the parasol.

10. Paint the figure loosely, naturally, avoiding details and leaving the most illuminated areas white. On the dress, add orange and violet tones while the hands and face should be painted with darker violet and muddy tones.

11. Now it is time for the lightest colors on the dress: light yellows and blues. Use the same colors to paint a glaze to depict the veil that covers her face. You must use the grainy texture of the canvas because, in combination with the thick semidry paint, it creates discontinuous colors to make a dotted screen of vibrant color.

12. The direct incorporations of thick white paint act as a luminous unifying field, increasing the strong effects of light on the back part of the ample dress. The white reflects the light and emphasizes the luminous appearance of the layer of paint.

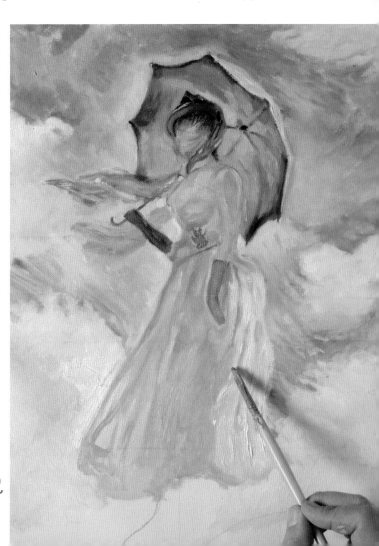

12

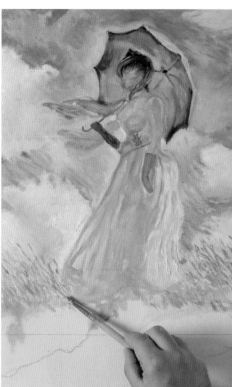

13

PAINTING DRY

The irregular and grainy texture of the surface of the canvas can be used in your favor. But you must apply the paint quite dry so that it will deposit on the highest areas of the surface to form a rough layer.

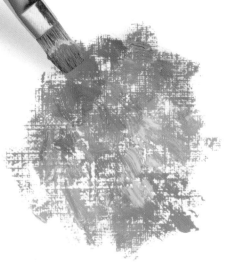

13. Paint the vegetation with light ochre, made by combining orange with a touch of violet and white. Hold the brush at a low angle, charged with paint, and make long wavy brushstrokes to create the grass blowing in the wind.

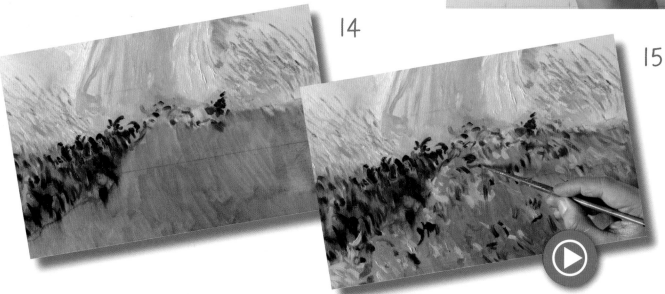

14

15

14. One of the main innovations of the Impressionists was using lighter and lighter colors in an effort to represent natural light. Therefore, it makes sense to use light base colors, like this green wash in the vegetation.

15. In the vegetation, the brushstrokes of emerald green, vermilion, white, cadmium yellow, and ochre are juxtaposed over and over. They are applied as thick dabs of paint, and the green tones blend with other lighter ones, little by little creating a dense mass of grass. In the video you can see how these brushstrokes are applied.

After the frenetic overlaying of brushstrokes on the vegetation, the work is finished. The contrasting colors and the juxtaposition of lightened warm and cool colors will suggest the shapes without recurring to the conventional manner of modeling the colors.

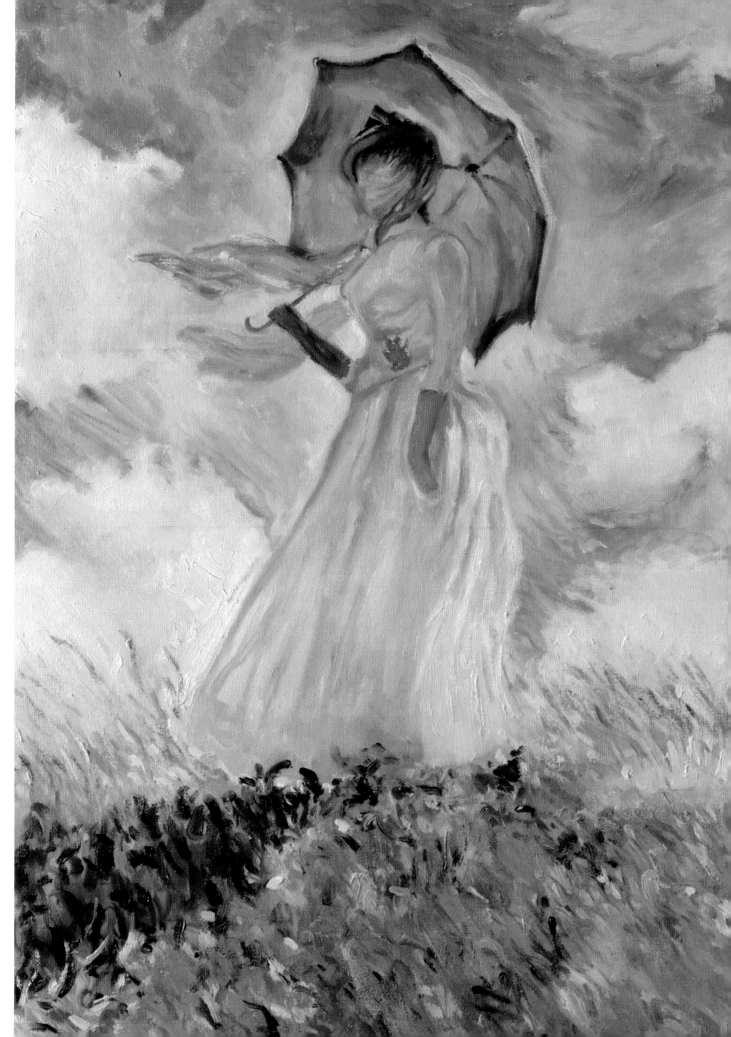

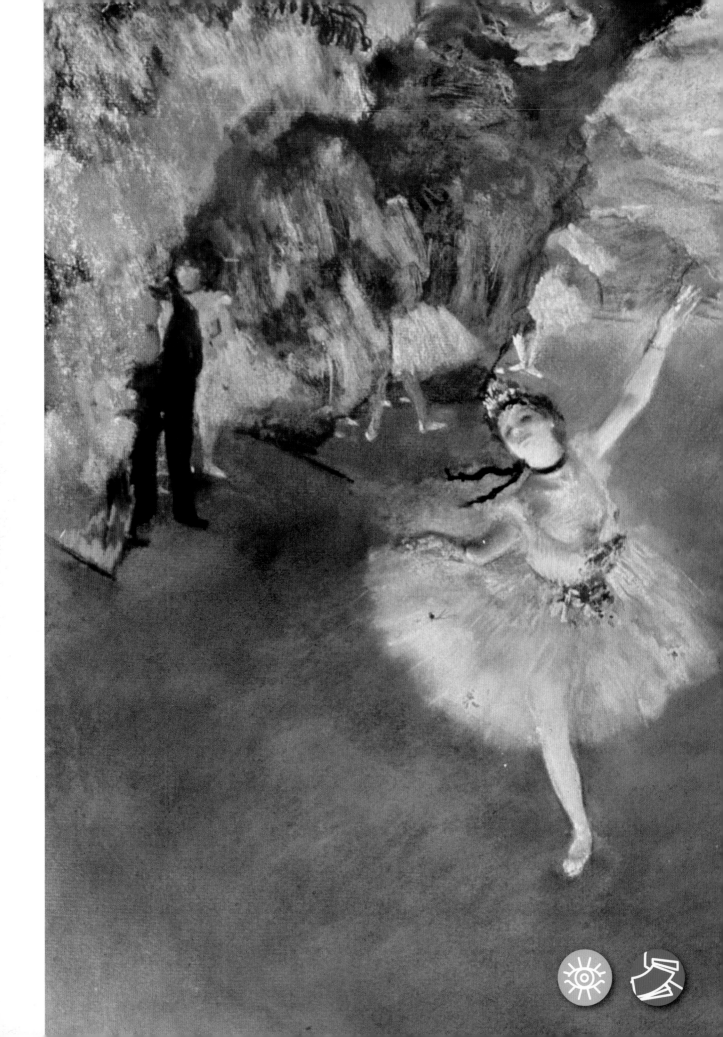

Although Degas began as an oil painter, he abandoned this medium in his final period and began making his paintings in pastel, in part because of problems with his vision, and in part because colors and the way they are applied allowed him to blend bold lines with a use of very strong colors.

This work is a good example of that; it depicts the graceful and stylized movement of a star ballerina, located in the center of a stage and seen from a privileged position, that of a spectator sitting in a theater box seat, that is, looking down from a high point of view. In this exercise, you will use sticks of dry pastel to copy the techniques of Edgar Degas and his ability to represent delicate female figures with sheer tutus bathed in soft interior lighting. The background appears to be treated in an abstract manner with daring blended colors.

Edgar Degas, *The Star* or *Dancer on Stage*, 1876–1877.
Pastels on paper, 23 × 17 inches (58 × 43 cm).
Musée d'Orsay, Paris.

The Star by Degas

First the Colors Then the Layers

There are several general rules for painting with pastels (some choose to start by applying the light colors and others by representing the shadows); however, Degas preferred to apply more or less flat areas of color, using the side of the stick, in the largest areas and to continue by superimposing the lines and shading with each new addition of color. He used a technique of working with successive layers of pastel sprayed with fixative, in a way that you can see through the top layers to the lowest ones.

1. This very simple subject does not require the use of any tracing, all you have to do is make a charcoal sketch and rub it with a rag so the charcoal dust does not muddy the pastel colors.

Degas used tracing to transfer sketches onto the canvas, which explains why many times his subjects seem inverted.

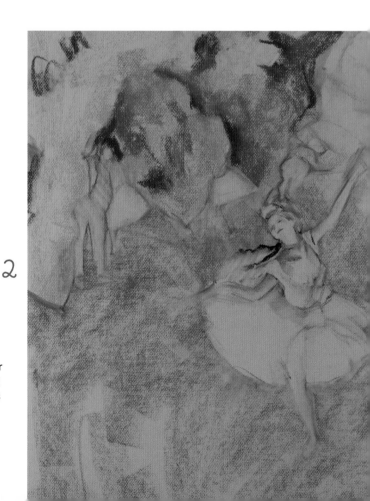

2

2. The first applications are made by dragging the side of the pastel stick on the paper. We want to cover the background with orange, sienna, and a little burnt umber and the floor of the stage with olive green. It is a good idea not to press too hard so the grain of the paper does not become saturated.

HOW TO CREATE THE TONE OF THE SKIN

At the beginning of the 20th century, Gustave Sommelier, a paint manufacturer known for making oil paint using pigments of the highest quality and for his palette of exotic colors of unequaled beauty that were very difficult to achieve, created a range of pastels especially for Degas. Those colors are still made today following the same methods as before, although some of the old mineral pigments have been replaced by synthetic ones, which match perfectly, like lapis lazuli and cinnabar.

3. Use a blending stick to mix the pastels on the paper. You just have to take the precaution of cleaning it once in a while so that the next time you use it you will not muddy other lighter colors.

4. The space in the scenery that covers the figure and the background becomes denser as you mix earth, gray and new strokes of green color, creating a neutral tonality that contrasts with the warm shapes in the upper area.

5. Complete the floor with nearly monochromatic applications where different layers of green are superimposed and highlighted with touches of gray and ochre. The accumulated layers of pastel make the material seem thicker, more palpable. Apply the first touches of light to the figure with blues and yellows. Work on the headdress and flowers on the dress with the points of the sticks, as shown in the video.

3

4

5

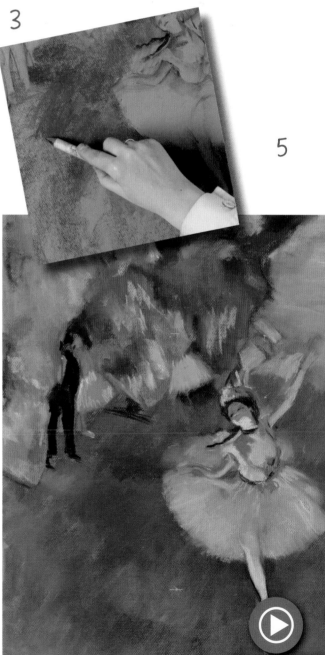

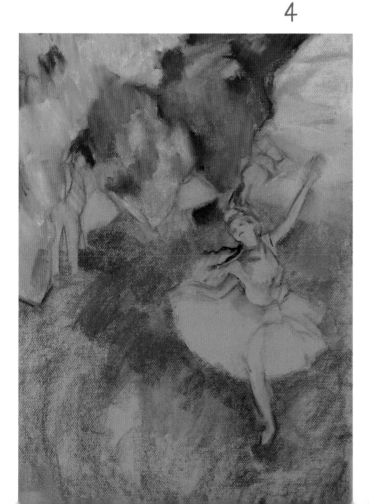

From the Grays to the Light

The palette of Degas in the early years of his career was full of brown tones, earthy pigments common to the tradition of realist painting that dominated in France in the middle of the 19th century. With the arrival of Impressionism, the artist's selection of colors lightened considerably as he went into his later years. Although the earth tones did not completely disappear from his palette, the greens, pinks, and oranges moved to the forefront. The blues and violets are not very dark; in fact they seem whitened as if they formed part of the light.

6

6. The drawing, which prevails in the confection of the ballerina, consists of touches of more intense colors that define the flowers on the dress and her head. They are applied by pressing hard with the tip of the stick so that the pigment will look saturated. Next, the flesh tones are lightened with the tip of the blending stick. The video shows how to work on the figure with the blending stick.

7

7. In the last decade of his activity, Degas moved toward abstraction; the forms were broken up more and more, which explains the loosely drawn background with strokes that are intense, overlaid, and very saturated. There the colors do not look blended, but rather appear compacted and built up.

TRICKS OF THE MASTER

One of the curious techniques used by Degas in his pastels consisted of using pastels to describe the subject up to a very finished state and then pour water or milk over the surface and spread it with a brush. This is how he blended the tones and achieved a painted effect.

8. The lines in the foreground of the painting are blended with the hand that achieves an extraordinarily suggestive atmosphere and isolates the central figure. Over this base of blurred colors, the ballerina is better able to communicate a sense of movement.

8

The finished work shows that knowledge of technique is as important in pastels as in any other medium. The technique refers to the personal marks that each artist leaves in different areas of the painting: blending on the floor, smooth gradations on the skin and on the tutu, and heavy intense lines in the background. The technical secret of this painting is in knowing how to make all the variations of these lines with the pastel stick.

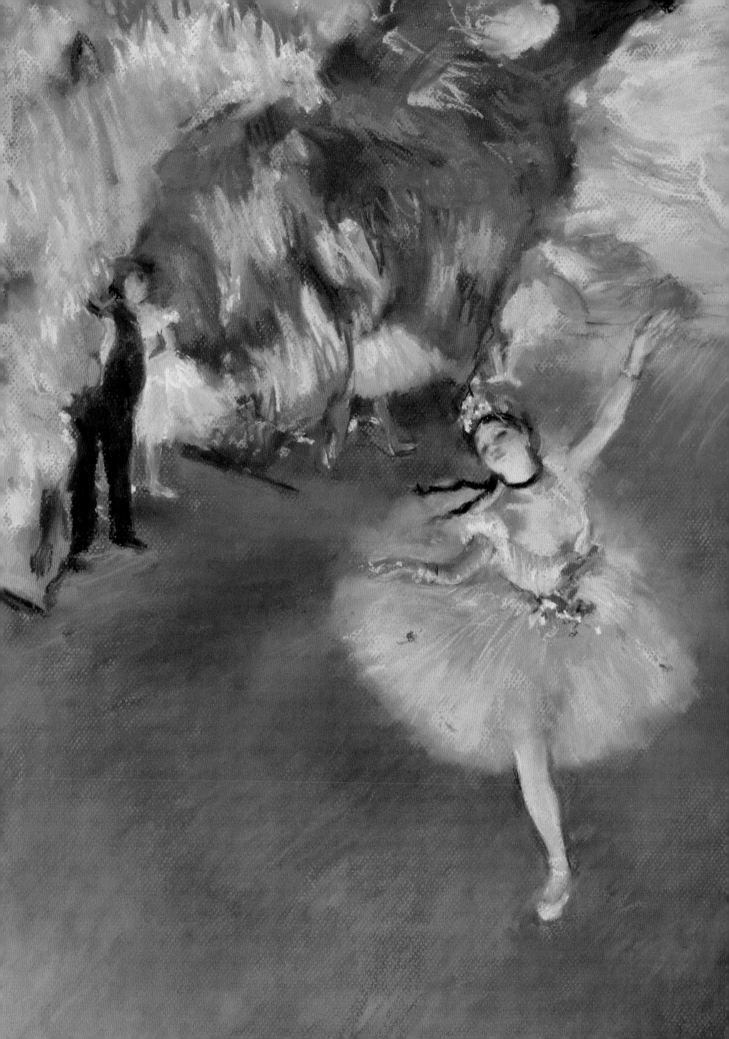

Georges Seurat. *The Bridge at Courbevoie*, 1886–1887.
Oil on canvas, 18.25 × 21 inches (46.4 × 53.3 cm).
Courtauld Institute, London.

9

10

9. Add a round of carmine-colored dots to the initial orange ones on the docks, and a new application, larger this time, of light cobalt blue. The units of color should be applied with a very fine round brush charged with thick paint. You must avoid working with paint that is too diluted.

10. Working with the pointillist technique is similar to working with glazes, since each application of color helps complete to previous ones. Now is the time to use darker blues to begin to suggest the distant silhouette of the bridge and to contrast the figures and nearby docks.

11

11. The light and warm colors predominate in the light areas, especially touches of orange, and the cool colors are more prevalent in the darker areas: blues, pinks, and violet. Light yellow begins to appear in the illuminated yellow areas, but it is also combined with oranges and appears among the blue dots. In the video, you can see how the accumulated dots of color give form to the landscape.

THE COLOR WHEEL

Seurat worked with a portable color wheel, similar to the ones sold today, that helped him easily find the complement of each color.

An Atmospheric Finish

Seurat dedicated himself to developing his method of "the color of light" or "chromoluminous" to scientifically record the unified effects of light and color in nature, as if they were small particles of light that float in the air, and they give his paintings a finish that is extremely atmospheric. There are no lines that create the edges, so the forms are identified by the contrast of colors or by the greater or lesser accumulation of dots. The smallest and closest brushstrokes depict more solidity, whereas those that are more spaced and applied over white express transparency and space, as on the water or in the sky.

12

12. Brighten the foreground with a new application of orange color dots. Make the brushstrokes smaller and closer together. Use the same color to paint over the dock and the central pillar on the distant bridge.

13. Now it is time to apply the dark colors in the more shaded areas. Work with dark cobalt blue and chrome green. At the same time that you are darkening certain areas, highlight the most visible reflections of light with white, especially those that help outline the wood fence and the figures that stand at the edge of the water.

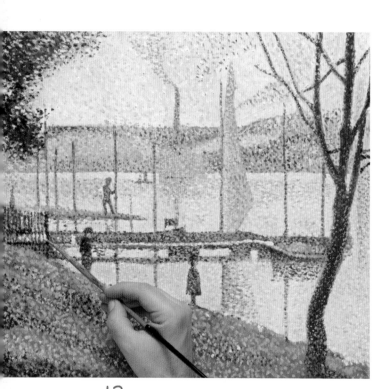

13

Seeing the finished work, you will understand that Seurat's paintings are based on the interaction of color, since the colors are not perceived individually, but in relation to others that are surrounding them. The constant interaction of oranges and blues stand out, they become brighter colors because they are next to their complement (and they would seem duller if they were next to another color from their same range).

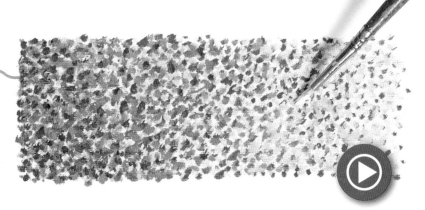

POINTILLISM

Overlaying small closely spaced dots of color allows you to create rich gradations and spectacular chromatic combinations. Watch the video to see how the dots of color blend and mix at a distance.

This is not only one of the artist's most emblematic works, but probably one of the best known, popular, and reproduced pieces in the entire history of art. Despite the apparent simplicity of the work, this vase with sunflowers is powerful and dynamic, constructed with vigorous, gestural brushstrokes as if the flowers were suns and their petals flashes of light. The flowers are not arranged haphazardly, each one is placed at a different angle: front, side, three quarters, profile, and even facing away from the viewer. No two are alike. In short, this is a work that became an homage to the sun of Southern France that Van Gogh adored so much.

Sunflowers
by Van Gogh

Vincent Van Gogh. Sunflowers, 1888.
Oil on canvas, 36 × 28 inches (92 × 73 cm).
Niue Pinakothek, Munich.

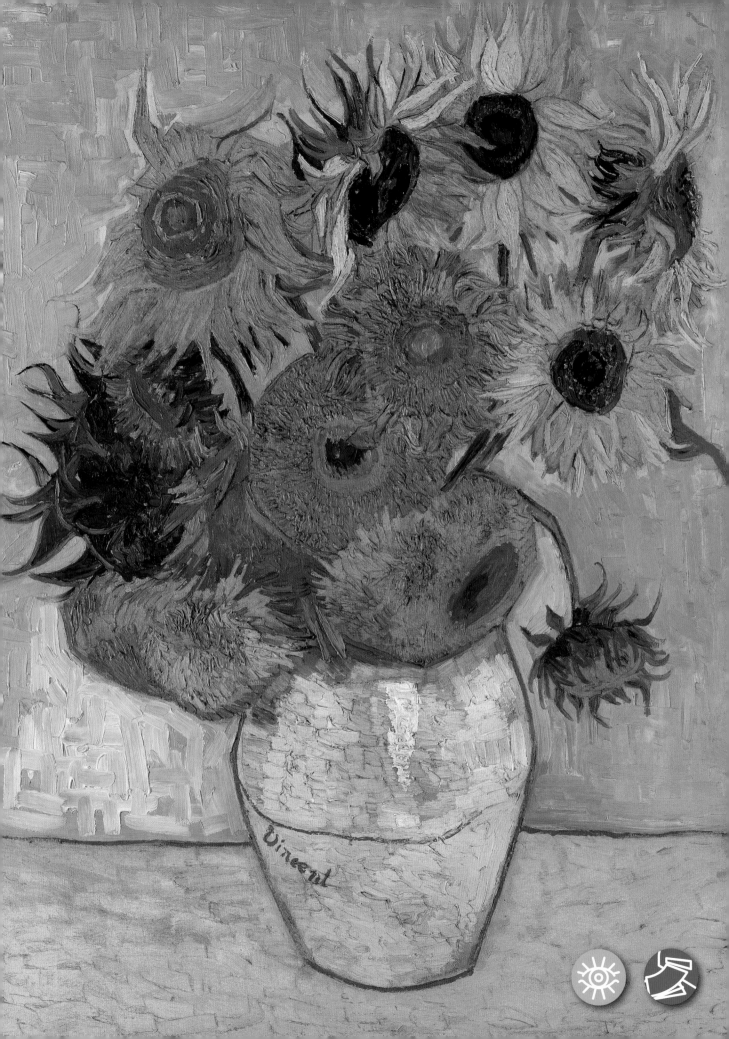

The Suggested Palette

Van Gogh painted with impastos, using colors that had a high lead content in the mixtures, like lead white (lead carbonate) and chrome yellow (made with lead chromate). These are very toxic pigments whose use runs the risk of lead poisoning, so here we will work with a range of modern colors that are similar to those used by the artist on the original canvas. The suggested palette consists of titanium white, medium cadmium yellow, yellow ochre, burnt umber, burnt sienna, permanent green, emerald green, Sevres blue, and cadmium orange.

1. Since we are working with an extremely simple and symmetrical still life, the drawing will be done directly with charcoal. It is especially important to indicate the location of the vase and to carefully draw its outline as well as that of the flowers. Spray the charcoal with fixative and cover the background with a mixture of Sevres blue and a dab of emerald green.

2. The blue for the background should also fill the spaces between the flowers. Using barely diluted cadmium yellow, cover the top of the table and the body of the vase. In these first phases we recommend using a wide brush.

1

3

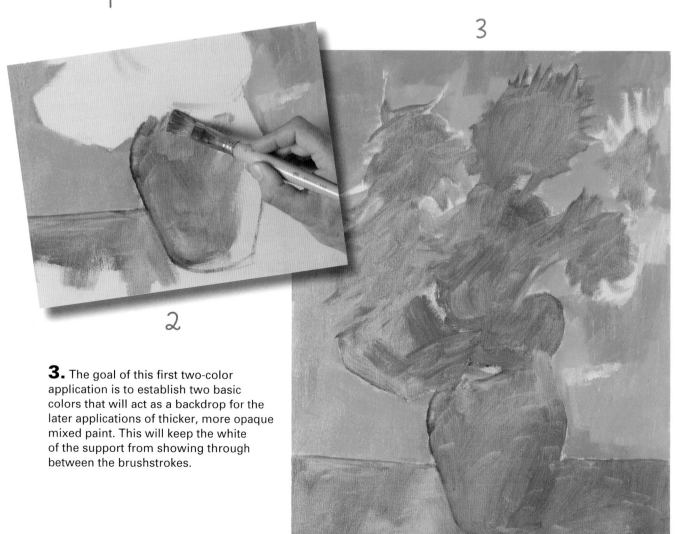

2

3. The goal of this first two-color application is to establish two basic colors that will act as a backdrop for the later applications of thicker, more opaque mixed paint. This will keep the white of the support from showing through between the brushstrokes.

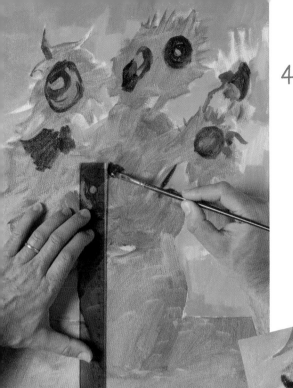

4

OCHRE AND ITS VARIATIONS

In this first state of the exercise, the forms are constructed with different tones of ochre, made by mixing browns with yellow.

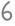

5

6

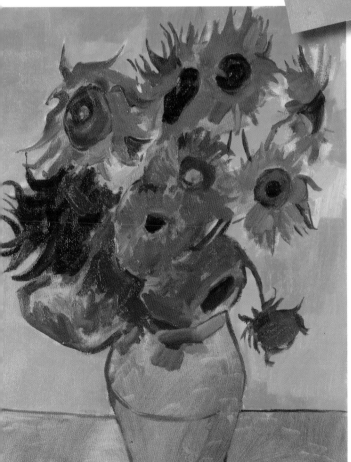

4. Mix burnt umber and a little ochre to create a dark brown. Dilute this color slightly and paint the centers of the flowers. You can use a ruler to calculate the location, height, and approximate diameter of each circular shape.

5. A range of ochres, modulated with burnt umber, burnt sienna, and a touch of blue and divided into light and dark tones and shades, are used to suggest the forms of the flowers with a few gestural brushstrokes. You can add a small amount of linseed oil so that the brush will glide more quickly.

6. Use the brown on the palette to draw the outline of the vase with a linear brushstroke. Mix a small amount of ochre with permanent green and paint the leaves with the resulting tone, using long curving strokes that finish with a twist of the wrist to represent their pointed tips.

7

A Palette of Pure Colors

The Impressionist and Post Impressionist painters used a palette of pure colors, where there were no dark, neutral, or gray tones that did not exist in the solar spectrum. This results in luminous paintings, with light and vivid colors. Thus, little by little, the initial range of ochres on the flowers will give way to yellow and orange. The background will be flooded with light blue brushstrokes, and the vase will be covered in a saturated yellow.

8

9

7. Mix yellow ochre with cadmium orange and incorporate it into the corolla of the flowers. The direction of the brushstrokes is intentional: wrapping or surrounding the center like whiplashes on the petals. You can see this process in the video.

8. You should always have a fine brush charged with the blue of the background for outlining and adjusting the shapes of the flowers. The result will be a strongly silhouetted object created by the strong contrast between it and the background.

9. Continue applying thick strokes of ochre, yellow, and orange, mixed with each other. Van Gogh did not use blacks or violets, so the darkest shadows of the flowers will be somewhat light in tone, resulting from the reflections of others around it and of the light that surrounds them. The general effect will be one of great brightness.

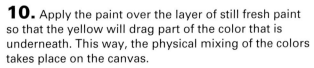

FINDING THE COLOR

To achieve the clear intensity of real light, the colors are not mixed on the palette but are applied separately to achieve the desired tone by means of the optical combinations on the canvas.

10

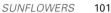

Now it is time to apply the cadmium yellow in its purest form. Charge the brush with a large amount of thick, undiluted paint.

11

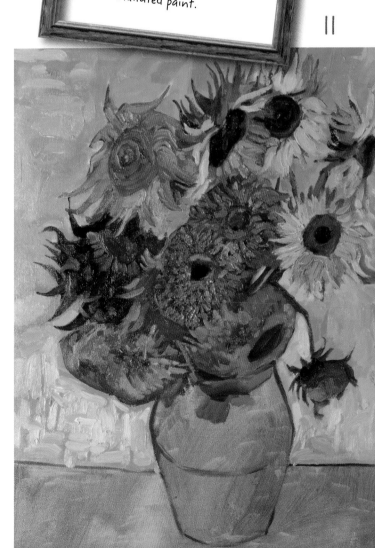

10. Apply the paint over the layer of still fresh paint so that the yellow will drag part of the color that is underneath. This way, the physical mixing of the colors takes place on the canvas.

11. Do the same thing with orange paint on the central flowers, but here make the applications short, cut off, and concentric. Mix Sevres blue with a large amount of white, and apply it thickly to the background with brushstrokes that break the chromatic uniformity and create light.

An Explosion of Sunlight

In Van Gogh's work, light was the necessary vehicle for the entire visual impression, which gave meaning to his paintings and emphasized the colors to the point of saturation, and it was, logically, his main concern. It is sunlight that, shining intensely on the flowers, creates the illusion of color and of line, and that is inherent in the differentiation of the colors in his work. For this reason, you do not have to work meticulously and in detail, but do introduce overlaid strokes, with vigorous beautiful touches made with a fully charged brush. Despite the unreal character of the paint, it radiates an explosion of warmth that converts the petals of the sunflowers into flames. The objective reality succumbs to expression.

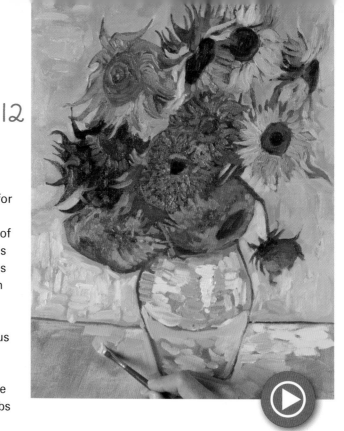

12. Paint the vase with thick and juxtaposed dabs of pure cadmium yellow, combined with yellows modulated with a lot of ochre and white. With this pure yellow and its mixtures with ochre and white, the Dutch painter expresses his enthusiasm for the direct light of the sun. You can see the action of the brushstrokes in the video.

13. Touches of pure cadmium yellow can be added to the upper flowers, those that receive the most direct impact of the sun. Finish painting the petals with emerald green lightened with yellow ochre, using a fine brush to create a long thin line.

14. The final touch of texture in the center of the flowers is all that is left. Scratch lines with the handle of the brush to emphasize the texture of the paint and add detail to some of the petals with the other end of the brush.

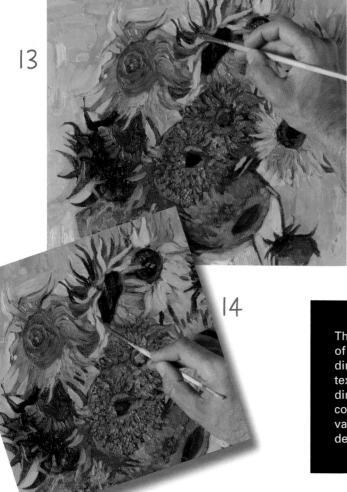

The secret of this painting lies in direct mixing, since most of the colors are applied thick and saturated so they blend directly on the canvas. The resulting color is very clean, textured, and impossible to achieve by mixing the pigments directly on the palette. Van Gogh worked with a range of colors limited only to those of the solar spectrum, making all variations of yellow very important. It is the color that best defines him.

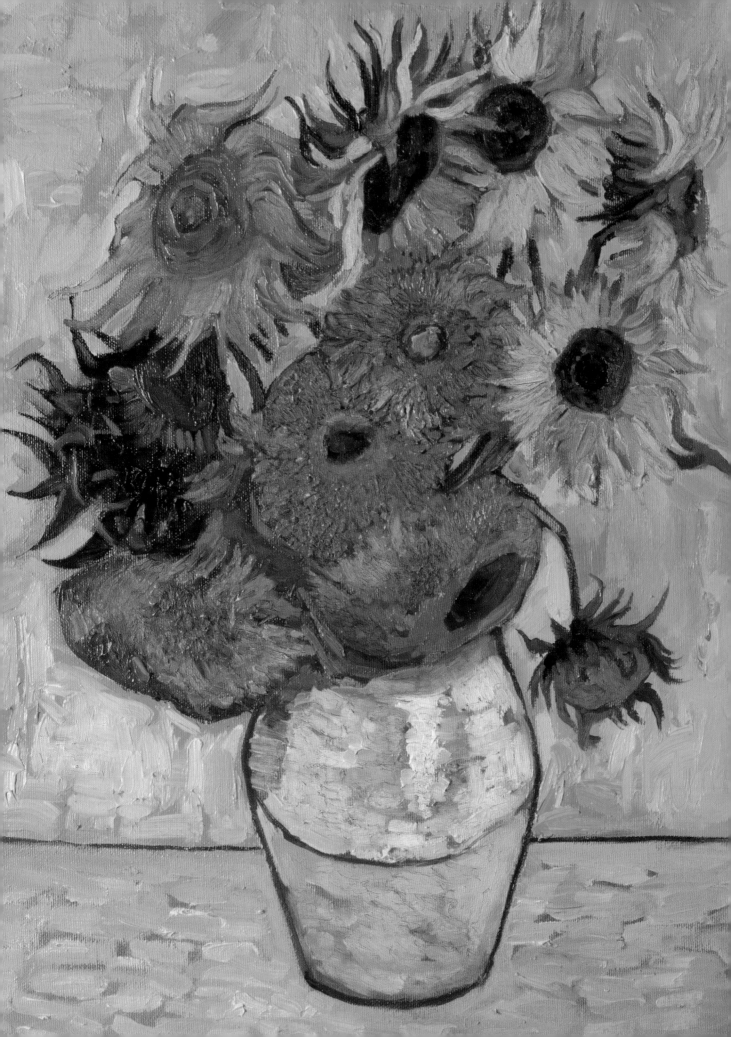

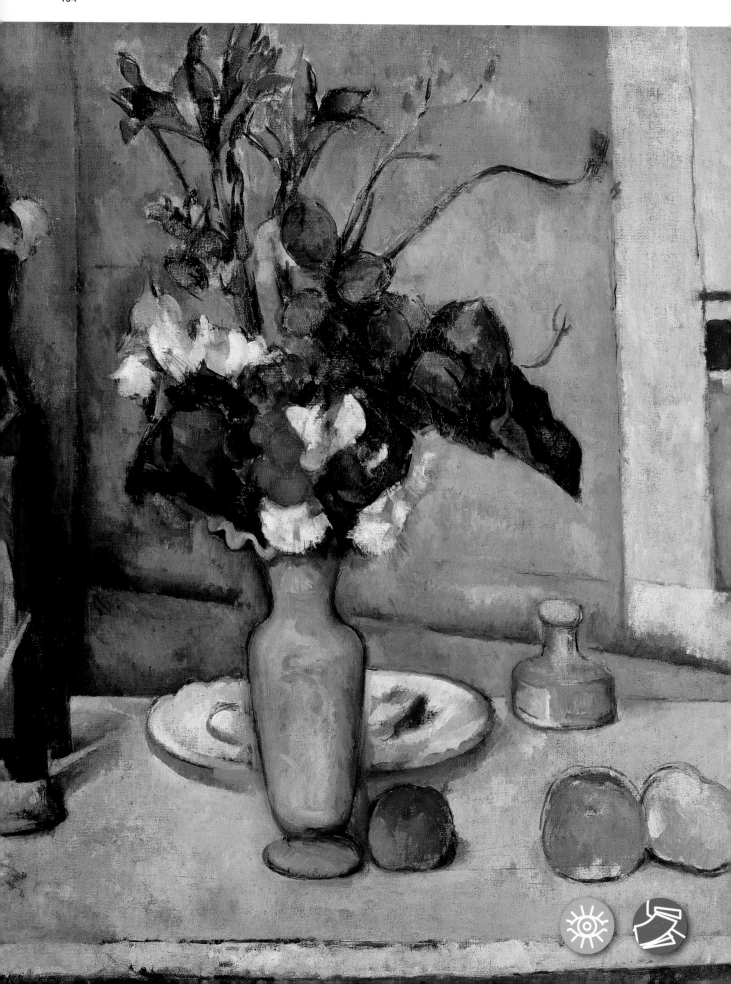

The Blue Vase

by Cézanne

Paul Cézanne, The Blue Vase, 1885–1887. Oil on canvas, 24 × 20 inches (61 × 50 cm). Musée d'Orsay, Paris.

This is probably one of Cézanne's most popular still lifes. It is a light ochre table with a blue vase that holds a beautiful bunch of flowers, several pieces of fruit, a plate, and a small glass container. More than just a representation of a grouping of flowers and fruit, Cézanne used this subject to study the modulation of color and the construction of an object with simplified and well-structured brushstrokes of oil paint.

Simplicity and Structure

Although Cézanne was not a well-known painter when he was alive, his work established the basis for the transition from the 19th century artistic idea to that of the new and radically different artistic world of the 20th century. Copying this painting is meant to help you understand the true intentions of the artist: representing the interior structure of objects based on a thorough control of the form and color, constructing the volume of the objects with planes translated into color.

1. Since the model is very simple, the preliminary drawing can be done directly with a stick of charcoal. The space is constructed with a skillful use of vertical and horizontal lines and by an exact arrangement of the volumes, taking care to respect the proportions among all the objects.

2. Dilute the first applications with turpentine, mixing cobalt blue with titanium white and yellow ochre. Use this color to cover the background, but, as you will see, the true harmony in the painting is created through the subtle use of this and additional blue tones.

SPREADING THE PAINT

In the first phase of the painting, Cézanne used wide brushes that allowed him to spread the paint quickly. In some cases, he even used very light brushes with soft hair that kept the paint from forming thick layers.

3

3. Prussian blue, mixed with lightened yellow ochre, makes a gray green that you can use to cover the left half of the background. The applications of color should be diffused and used to outline the silhouettes of the vase and the flowers, which are the main subject of the painting.

4. The wide juxtaposed brushstrokes of lightened blue, green, and ochre, which should be very diluted, configure the surface of the painting and break up the image in a continuous series of small planes of color and light gradations that construct the atmosphere of the background. In the video, you will see how the brushstrokes blend with each other.

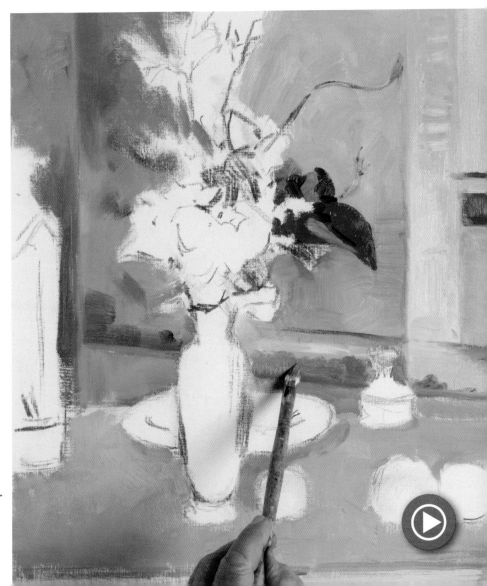

4

Palette of Blues

To paint this picture, Cézanne basically used two varieties of blue: cyan and Prussian blue, which little by little creep into all the mixtures to the point that the painting clearly has a blue tendency. However, it is not rare to find up to four tones of this color when you include cobalt blue and ultramarine blue. As for the rest of the palette, he used cinnabar red and green, emerald green, yellow ochre, and, of course, titanium white. Following the advice of Pissarro, burnt sienna, burnt umber, and ivory black only appear occasionally to outline or as a contrast, or as Cézanne himself said, "to give form to the painting using a few light lines of color."

5

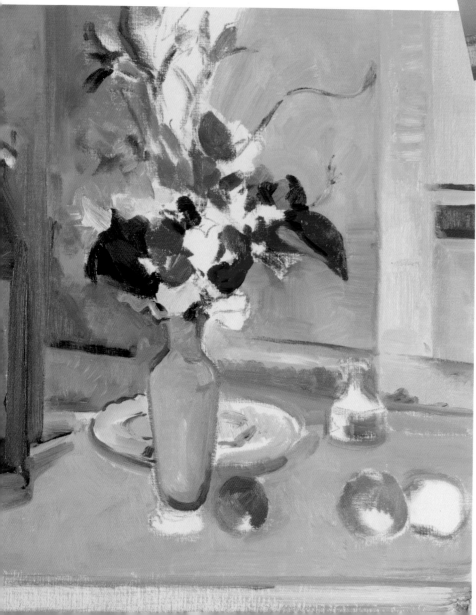

6

5. Use a mixture of cadmium red, ochre, and black to paint the red flowers, and emerald green and cinnabar green, ochre, and black to suggest some leaves among the flowers. The verticality of the vase, which is a lightened cerulean blue, counteracts the strong horizontal of the ochre-colored table.

6. Use a fine round brush and a range of grayed colors to sketch the longest and most curved stems of the bunch. The unfinished look of the flowers integrates them little by little into the blurry background with its blended blues, perhaps as a symbol of its perfect harmony with its surroundings.

7. The forms should be simply represented and strongly expressed, the colors should be austere, and some of the edges should be outlined with a mixture of Prussian blue and a little black to separate them from their surroundings. Use the same color to sketch the stems of the flowers as well.

8. Add some more strokes of thick paint in dark blue, white, ochre, and red on the flowers. Loosely finish the object on the left with earth colors and gray tones; here you can see it is cut in half by the edge of the painting.

7

8

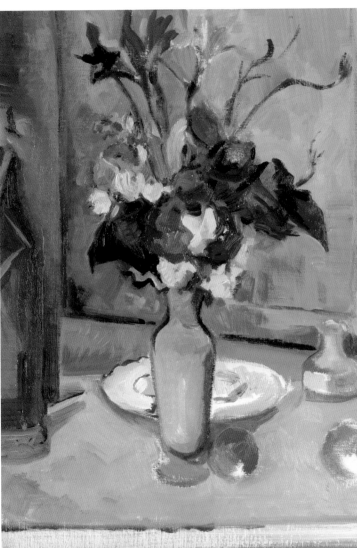

THE FAVORITES

Cézanne made great use of the blues: cyan, cobalt, and Prussian; which he mixed with white, ochre, and other dark colors.

Constructing with Colors

For Cézanne, representing a model depended on using color in an orderly and expressive way, constructing it with brushstrokes that were not restricted to details, in a superficial manner. The applications of paint are mainly flat, barely used for modeling, and they are applied as blended brushstrokes that avoid traditional chiaroscuro. Here the artist ignored emotion and feeling to reflect on the pictorial language, meditating on the relationship between form and color.

9

9. Use a flat brush to complete the fruit with just a small amount of red, ochre, and a touch of blue. The brushstroke should be direct, thick, and very stylized. There is barely any modeling; each area of color seems clearly outlined.

10

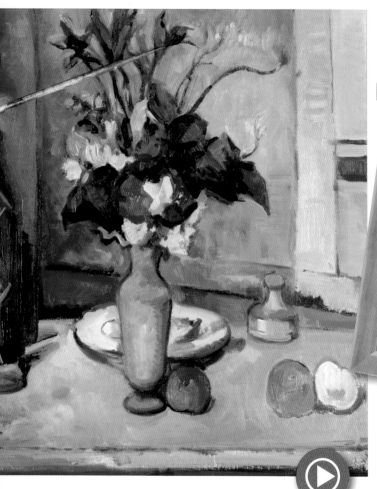

The artist believed that the traditional idea of a completed painting was no longer valid and opened the doors to the unfinished, a concept that had a great influence on all art in the 20th century.

10. Finish the leaves of the arrangement with grayed Prussian blue. To integrate them with the blue of the background, apply brushstrokes of lightened blue around them so that their outlines become somewhat blurred. Notice the tendency to complete the flowers with fragmented brushstrokes, typical of the Impressionists. The graphic treatment of the arrangement can be seen in the video.

After the work is finished, you can see the obvious simplicity and austerity of the flowers, the vase, and the fruit, which are far from the exuberant and rich treatments typical of other artists of the period, like Auguste Renoir. The copyist should concentrate on resolving the forms of the objects that appear in the still life, working at finding the exact tones of blue and ochre, and using the appropriate brushstrokes for each area in the painting.

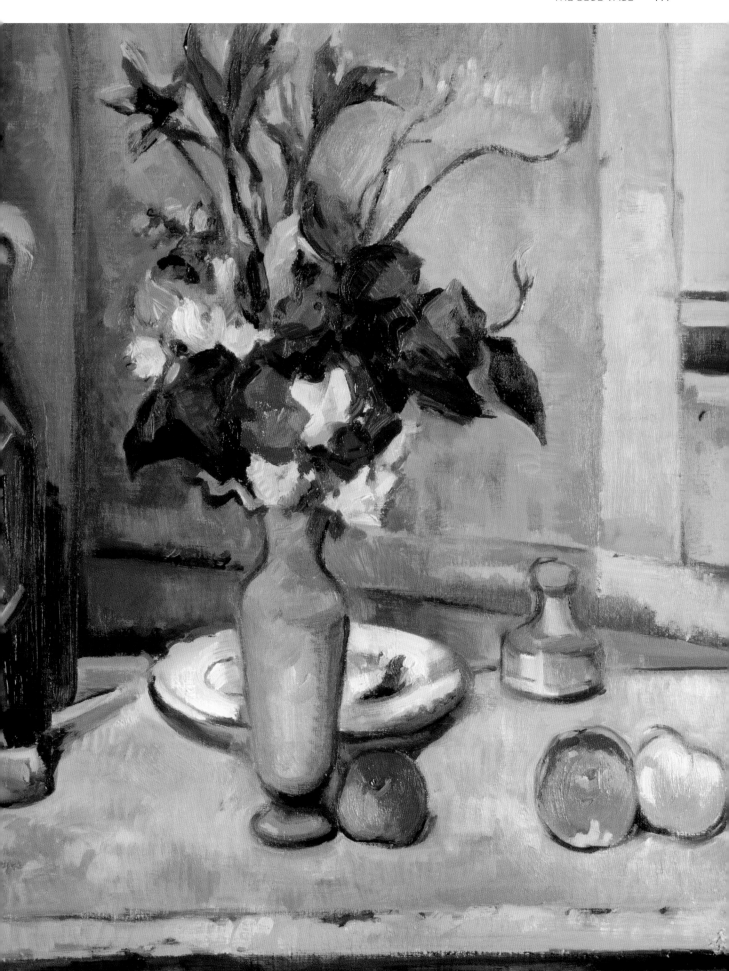

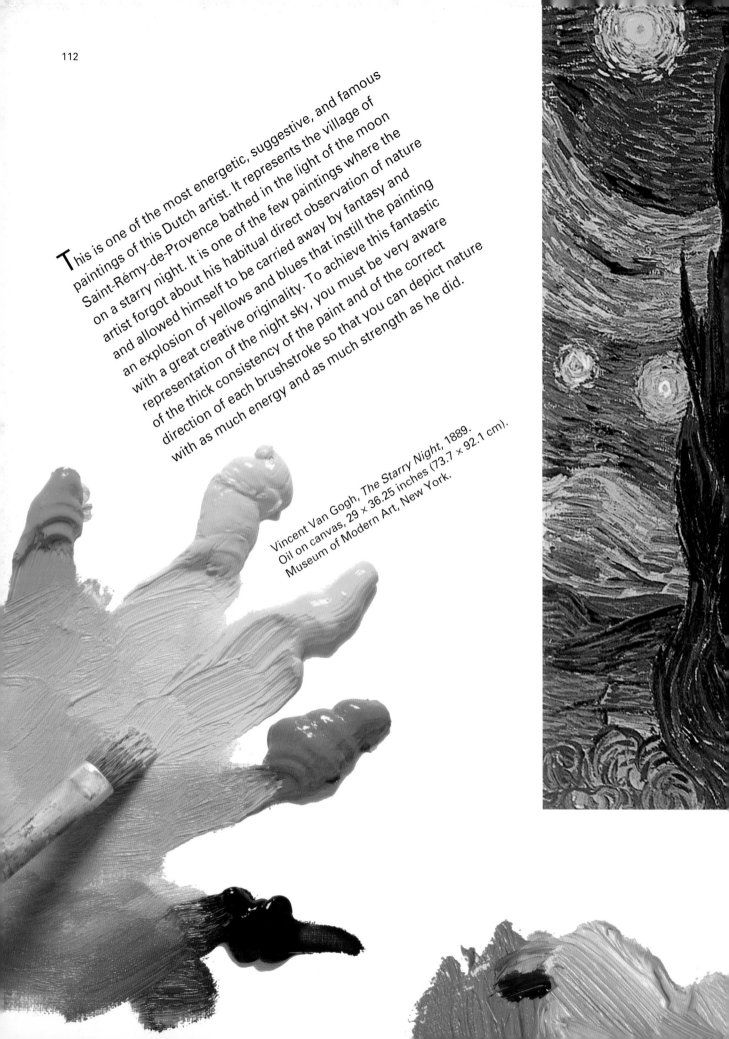

This is one of the most energetic, suggestive, and famous paintings of this Dutch artist. It represents the village of Saint-Rémy-de-Provence bathed in the light of the moon on a starry night. It is one of the few paintings where the artist forgot about his habitual direct observation of nature and allowed himself to be carried away by fantasy and an explosion of yellows and blues that instill the painting with a great creative originality. To achieve this fantastic representation of the night sky, you must be very aware of the thick consistency of the paint and of the correct direction of each brushstroke so that you can depict nature with as much energy and as much strength as he did.

Vincent Van Gogh, *The Starry Night*, 1889.
Oil on canvas, 29 x 36.25 inches (73.7 x 92.1 cm).
Museum of Modern Art, New York.

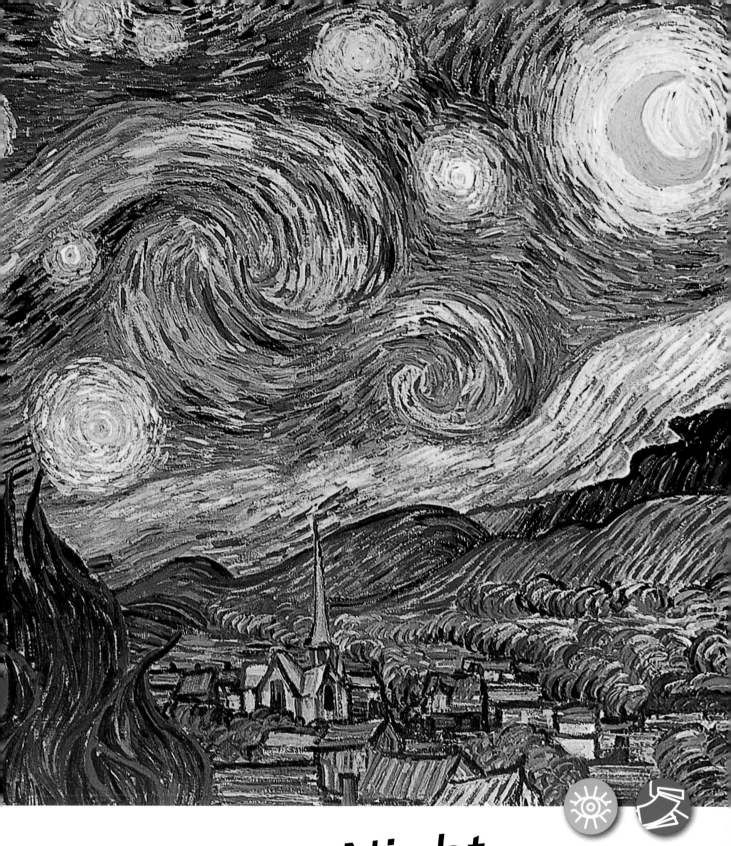

The Starry Night
by **Van Gogh**

Van Gogh's Layout

The drawing can be made directly on the canvas with a pencil. You only need to sketch a few compositional lines; for example, you can draw the same layout of crossed lines that Van Gogh used in his paintings. This allowed him to arrange all the elements around the center of the painting, making sure that none of them fell on the point where the lines crossed. The painting is divided into two very different parts: the starry sky, which occupies nearly two thirds of the surface of the canvas, and the village, presided over by the long needle formed by the tower of the church. There is a destabilizing element in the foreground, the great cypress that breaks up the division by rising up wave-like to the top of the painting.

1

1. To lay out the drawing, use a scheme consisting of two superimposed crosses, one perpendicular to the frame of the painting and another formed by diagonal lines. This is a scheme that Van Gogh used very often in many of his paintings.

2

2. Use a long ruler to draw the straight lines that converge on a single point in the center of the painting. The preliminary drawing should be made with an HB pencil, pressing lightly so it will not damage the surface of the support.

3. Starting from this preparatory scheme, begin laying out the different components of the painting, trying to place them in their corresponding quadrants. Notice that the stars in the sky are distributed along the diagonal lines in the composition.

3

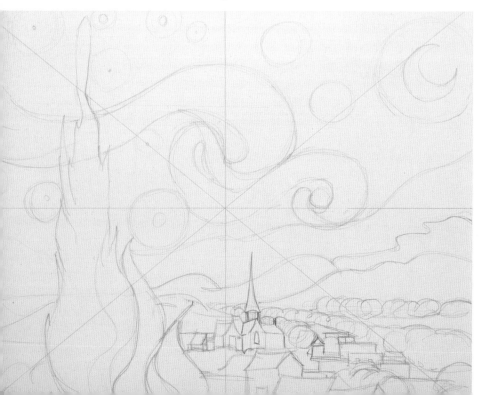

4. Van Gogh painted the original work directly on white canvas, but over time the white has become yellowed and darkened. To recreate the look of the original model, cover the background with a layer of thinned beige paint to reduce the impact of the white fabric.

5. The initial pencil drawing is now darkened with the first blue brushstrokes: cobalt blue and Prussian blue mixed with a touch of burnt sienna to gray it.

6. The lightest blues of the sky are painted with cyan, and they locate the luminous halos of the stars and the spinning forms in the center of the painting. Use a darker blue to draw the village, composed of houses with curved roofs and the long needle of the church tower presiding over everything.

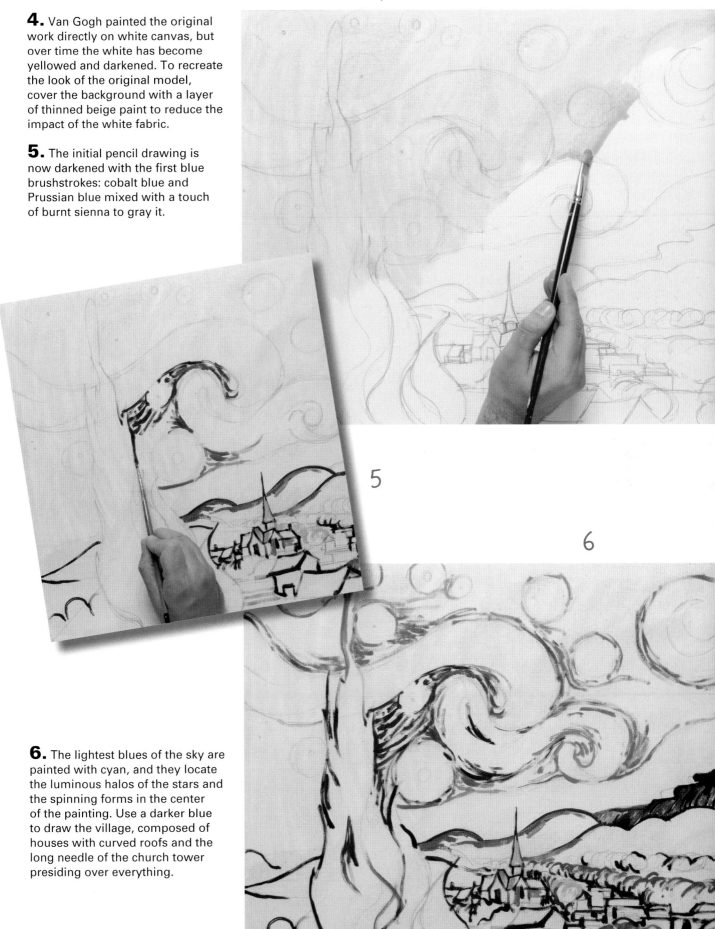

A Concert of Blues and Yellows

The blues (cyan, cobalt, ultramarine, and Prussian) and the yellows (Naples and cadmium) were used by Van Gogh in all his paintings of this period. He used to mix them with each other to create light green tones, or with white to make them lighter. Thus, the artist applied color in *The Starry Night* by superimposing brushstrokes of different tones of blue and yellow that make slight transitions toward the white, orange, and violet that are also in the mixtures. In conclusion, the presence of pure colors is fundamental, with very little mixing of them, only altered by the strength of the dark greens, black, and reddish sienna used on the cypress.

7. Tint the mountains in the background with wavy and superimposed strokes of cobalt blue, Naples yellow red, gray, and a little green. Allow the white of the support to show through between the brushstrokes, this should be done consistently in all areas of the painting. Meanwhile, the first bits of yellow should be timidly appearing in the sky.

7

8

9

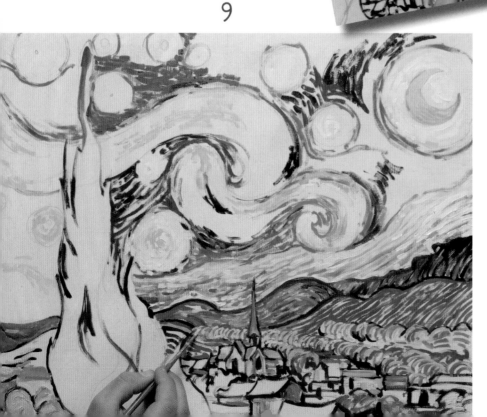

8. In this phase, the yellows and the blues are mixed with a lot of white. Begin by covering the horizon and move up progressively toward the stars. The goal is to create an overall tone of the light that comes from the sky. Work with a fine round brush.

9. Paint the vegetation that is around the houses with green mixed with white and cobalt blue. The outlines of the buildings should be marked with thick strokes of dark blue tones that are nearly black, as well as the outlines of the mountains, which is reminiscent of the Cloisonnés used by Gauguin.

10

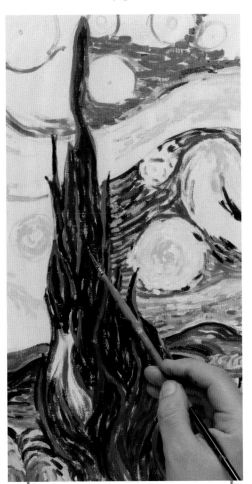

In the video, we show how to paint a star.

GRADATIONS OF YELLOW

These rich gradations of yellow are created by combining it with other adjacent colors on the color wheel like ochre, green, and even its complement, violet.

10. Mix Prussian blue and permanent green to paint the darkest parts of the cypress with ascending curved lines. The outline of the tree can be completed with red brushstrokes shaded with a little burnt sienna.

11. The line of the mountains crosses from one side to the other of the canvas; it is important for this line to be different from the color of the sky, which is much yellower on the horizon. The texture of the long dark brushstrokes on the cypress creates contrast and makes it look like the hills and stars are drawn on a different plane than the much closer tree. In the video, we show how to paint a star.

11

Cloisonné consists of outlining shapes with a black or dark line as in old stained glass windows. This way, the line was given more strength in paintings where much brighter colors were used.

Mixing, Dragging, and Texture

In this painting, we should emphasize the treatment given to the light of the stars, which look like small points of light wrapped in a luminous halo created by building up concentric brushstrokes of white, yellow, cyan blue, ultramarine blue ... all of them thick and mixed with each other because each new application of color drags the wet paint underneath. The thick overlaid brushstrokes, applied with a fine brush, give the painting a rough look.

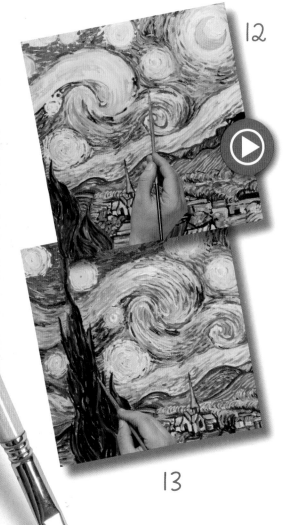

12

12. Go over the outlines of the two enormous nebulous spirals wrapping around each other with curving, linear strokes of ultramarine blue. Use the same color with touches of dark blues and greens to emphasize the halos of the stars. The moon, painted with cadmium yellow, orange, and whitish yellow, is as strong as a radiant sun. In the video, you can see how to apply the brushstrokes on the large spiral in the center.

13. Apply a layer of yellow diluted with turpentine to act as a base for the blue brushstrokes. Immediately move from more or less short, linear brushstrokes to longer and thinner ones; this way the surface texture will look like a sort of whirlwind, or as if there is a great dizzying movement of light.

13

SUPERIMPOSING LAYERS

The new layers of paint are superimposed over others that are still fresh; this way you can cause the underlying color to be dragged so that both colors mix to form streaks.

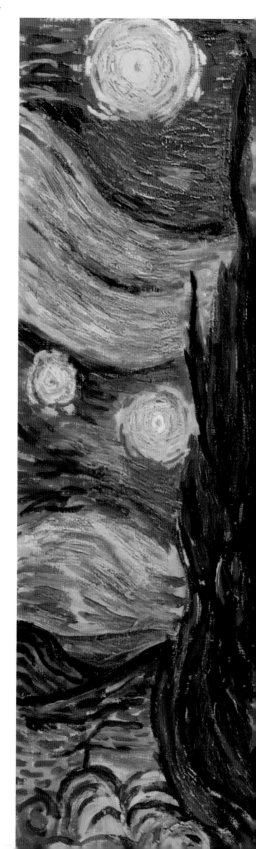

The final result is everything but realistic. The imagination of the artist converted this starry night into an agitated and dynamic painting where the brushstrokes flow like water, like a stream that forms whirlpools in the sky, in the presence of a flame-like cypress and a village with a supernatural atmosphere.

The protagonists of this scene are some ladies of the evening who await the arrival of their clients. Toulouse-Lautrec frequented the bordellos and knew their inhabitants and the atmosphere of their surroundings very well. The strong and direct drawing is one of the most defining characteristics of the paintings by this artist, although we must also point out that the colors, especially the pink, red, and violet tones, create a strong harmony in the work. These colors create a warm atmosphere, along with the coral pink that covers the walls that is in clear contrast to the green that defines the architectural elements. Despite the fact that this is a meticulously planned work based on many previous drawings, the finish has a sort of improvised feeling, which is characteristic of all of the work by Toulouse-Lautrec.

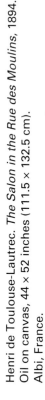

Henri de Toulouse-Lautrec. *The Salon in the Rue des Moulins*, 1894. Oil on canvas, 44 × 52 inches (111.5 × 132.5 cm). Albi, France.

The Salon in the Rue des Moulins

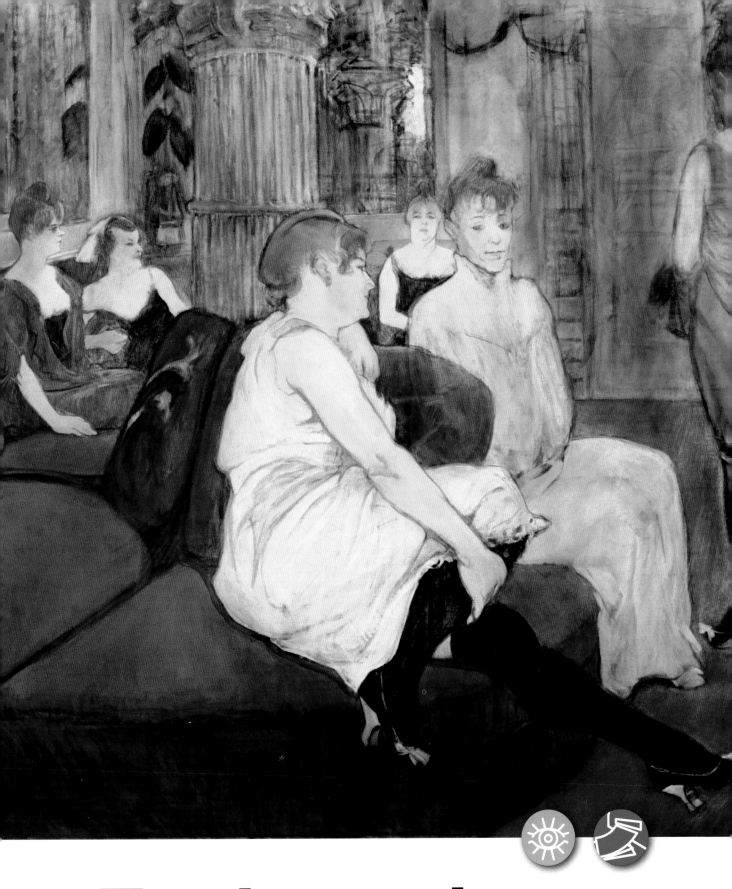

by **Toulouse-Lautrec**

First, Dilute the Paint

After making the preliminary drawing, Toulouse-Lautrec used oils that were very diluted with turpentine to fix the lines and apply the first colors. This gave the canvas an interesting texture, because between the part that was absorbed by the surface of the painting and that which evaporated, the result was a very matte initial oil glaze. The artist called this technique of staining with oils diluted with turpentine *peinture á l'essence* (painting with essence of turpentine). It had some advantages: the canvas dried very quickly because the turpentine evaporated immediately, and the painted colors looked bright because of the transparency of the thin layer of paint that reflected the white of the support.

1. The base of this work is a strong line drawing done in charcoal, which in addition to sketching the figures, marks the rhythm of the composition and indicates the overlapping planes. The diagonals are used as a compositional technique, and you must be aware of them when situating the figures in the space. Use a blending stick to add the shading and to reduce the intensity of the lines. When the drawing is finished, wet it with spray fixative so the charcoal does not come off.

2. The first brushstrokes will be reddish brown and ochre. The oils should be diluted with a large amount of turpentine, and when it evaporates the colors will be uneven and you will be able to see the brush marks. Each of the planes will be covered by a pattern of parallel brushstrokes rather than a single even tone.

2

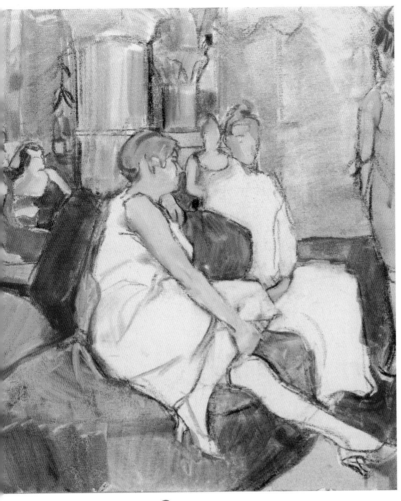

3

GLAZING

In some areas, the lines of the charcoal drawing will be barely covered by a light glaze of brownish tones very diluted in essence of turpentine.

3. Cover the dark parts of the divans with sienna while painting the background with strokes of pink and green. Both colors should be much more diluted than the sienna, and the brush should be only lightly charged with the paint. You must avoid going over and over the charcoal lines with the paintbrush.

4. Paint the white dresses with lightly tinted turpentine and the dark stockings with diluted black. Color is the real protagonist of this painting, not only because of its symbolic component but also because its flat application and the brightness of the tones give the work a preliminary chromatic orientation, a base to work on.

4

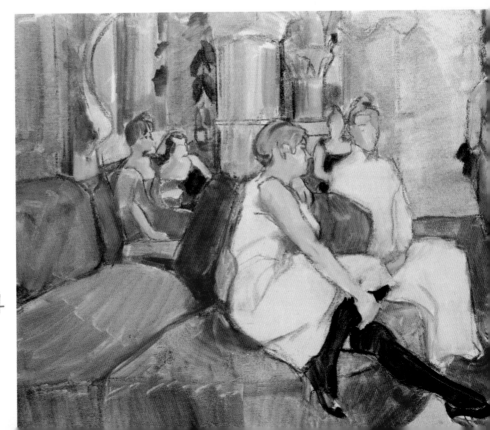

Poppy Seed Oil

In France in the 19th century, oil paints were manufactured by mixing the ground pigments with the agglutinant, which at the time was poppy seed oil rather than linseed oil. This oil gives the oils a creamier texture, instead of the smooth and uniform surface that is typical of the mixtures with linseed oil. Nowadays, this is not feasible, and the oil paints sold today contain linseed oil. Here you will use poppy seed oil as a medium to add consistency and to thicken the successive layers of paint.

5. Begin covering the divan in the center of the scene with pink earth transparent mixed with a little white and thickened with poppy seed oil, which will allow you to better outline the figure of the woman. Paint her dress with a thick layer of white.

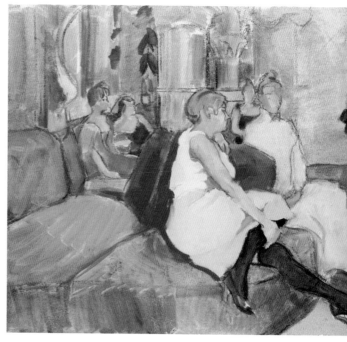

5

6

6. Mix the pink earth transparent with white and a little violet to create tonal variations that will enrich the different intensities of light that falls on the divans. The deepest shadows can be resolved with a mixture of burnt umber and cobalt violet.

A NATURAL THINNER
If you add a little poppy seed oil, the paint will become more fluid and at the same time maintain its opacity. It can be used as a thinning medium.

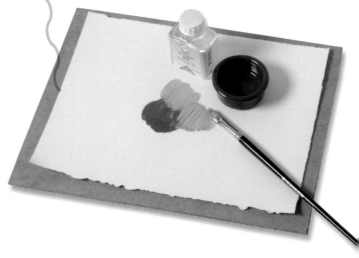

The paint is more diluted and does not completely cover the underlying color. The base coat of diluted paint still shows through the brushstrokes.

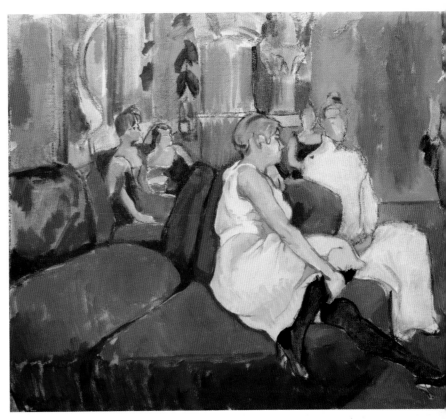

7

7. New applications of green, salmon, gray, and pink earth transparent paint are used to fill in the background. The edges of the brushstrokes blend with other adjacent ones.

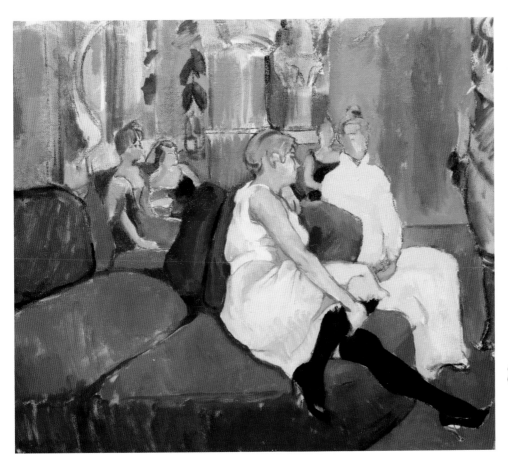

8. The simplification of the forms, the flattening of the pictorial space, the planes of flat color, and the linearism or outlining of the forms with a brush charged with a mixture of violet and pink earth transparent are all techniques that were used to arrive at this point.

8

CHARCOAL OVER OIL

When you draw with charcoal over fresh oil paint, the pigment of the charcoal gets damp and becomes part of the painting. The line is permanent after the oil has dried.

Flesh Tones and Facial Features

Now it is time to approach the flesh tones and the facial features, combining the oils with some lines drawn with charcoal. Notice that in this painting there is greater interest in capturing the faces of the women than their bodies, which have been treated more simply and with looser brushstrokes. The drawing combined with oil paint has nothing to do with traditional academic drawing; adding lines over a layer of fresh paint is done to outline the brushstroke in a way that is more expressive than purely descriptive.

9. Apply a uniform color on the skin of the two figures in the foreground. Using the tip of a charcoal stick, redraw some of the lines that best define the face and some of the outlines.

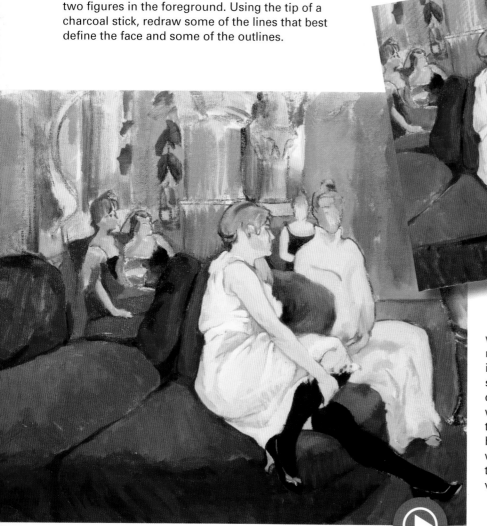

9

10

10. Complete the divans with new applications of color, modeling with smooth transitions in tone. Use a simple style, almost smooth and barely modeled in comparison to the clothing of the women, which is painted with thick directional brushstrokes that help better describe the folds and wrinkles of the clothing. Watch how the folds are approached in the video.

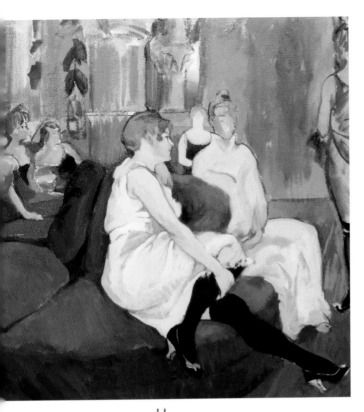

11

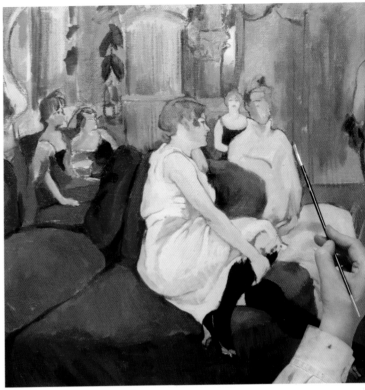

12

11. Depth is created by placing the women in parallel planes, distorting the background of the salon with sketchy brushstrokes that contrast with the more detailed figures in the foreground. The background on the right will maintain this vague, unfinished look until the end.

12. Use just two tones for the skin to construct the face of the girl in the foreground. Define the profile of the head with charcoal, delicately and pressing very lightly.

13. With a fine brush, work on the two figures on the left in the back. Their individual features are not given much attention, while the details of the background consist of stylized shapes and loose brushstrokes. Try to represent the elements in a superficial manner, without many details.

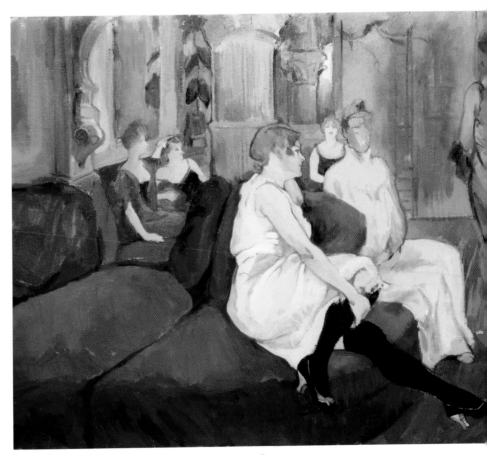

13

The Details Are Brush Marks

The richness of this bordello caused a sensation among its visitors, especially its luxurious bedrooms, decorated according to all kinds of decorative styles. Toulouse-Lautrec communicated this atmosphere without going into the details of the architectural elements and the flourishes. He defined the details with accents of red, pink, and yellow as needed, or with a mere gestural brushstroke that suggested some plant or decorative feature.

14

14. In the flesh tones, the pinks on the skin reflect the violets from the colors that surround the figures. The eyes and the crimson on the lips of the women in the background can barely be distinguished; the nearest two, on the other hand, show more careful line work, although the eyes seem inert and lifeless. Watch the video to see the creation of the face of one of the figures.

15. The figure in the foreground requires more attention than the rest. The brushstrokes are light and emphasize the relief of the dress, which has contrast thanks to the use of violet lines that wrap each fold. The outline of the face and of the hair are finely drawn, with a darker line than that on the skin.

15

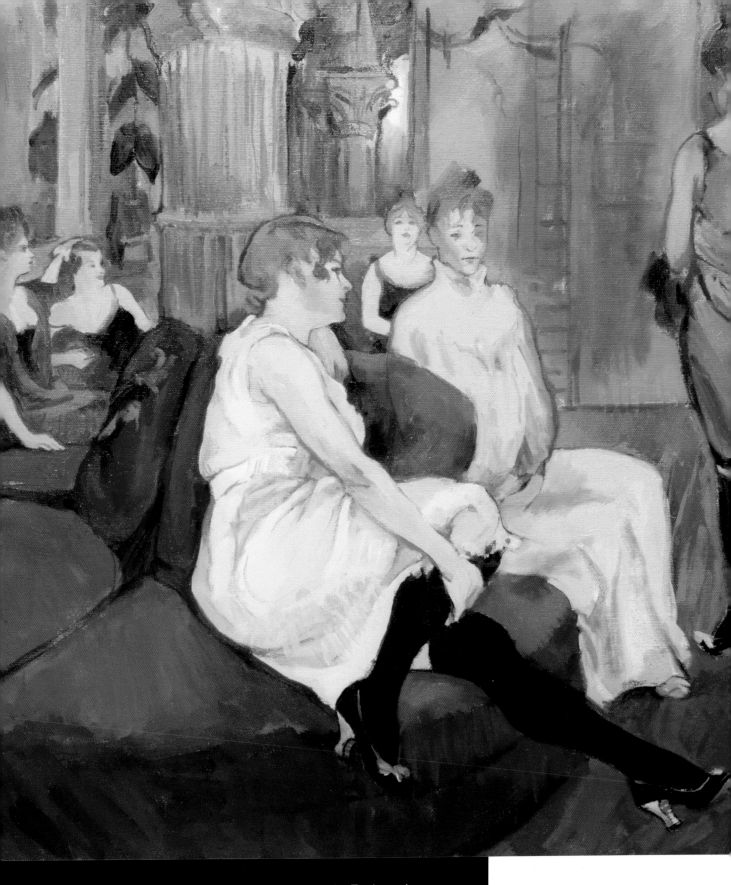

The finished painting is dominated by color, no wonder Toulouse-Lautrec, along with Gauguin, is known for introducing large areas of flat color into painting. The space is characterized by large empty areas consisting of the velvet divans on the left, and an opening in the background where the light enters. These elements give the painting a feeling of depth. In brief, this is a good example of how Toulouse-Lautrec used color and atmosphere to depict the warm ambiance of this interior space.

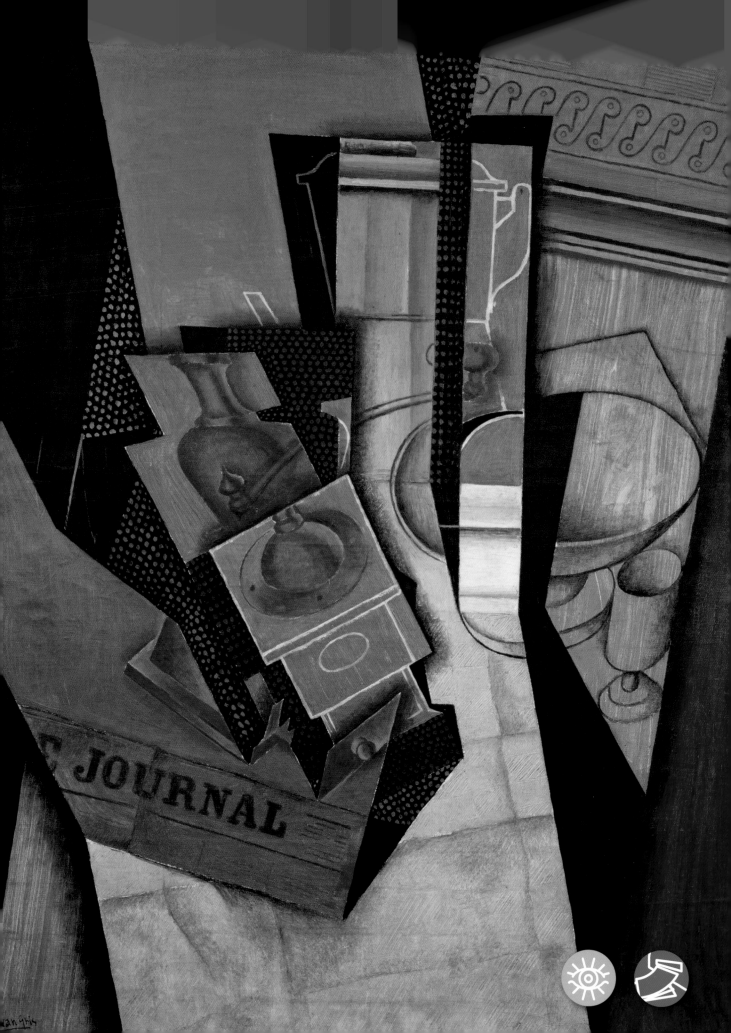

Juan Gris was one of the main exponents of Cubism along with other artists of stature like Picasso and Braque. Just like his counterparts, he popularized a new kind of still life, based on a new artistic and philosophical concept based on giving priority to the concept over the real image of the model. The painting became something more than a mere representation of the object, it was a faithful copy. In this work, the artist deconstructs and interprets the reality. He takes apart the space and converts it into disarranged geometric shapes, a contrast between flat and volumetric forms, pieces of color cutouts and shaded and conveniently modeled objects. This exercise will be done with oil paint.

Breakfast by Juan Gris

Juan Gris. *Breakfast*, 1915. Oil on canvas, 36 × 29 inches (92 × 73 cm). Musée National d'Art Moderne, Georges-Pompidou, Paris, France.

A Fragmented Model

The following drawing has a structural, geometric composition that contains obvious Cubist elements like inverted planes, fragmented objects, and different simultaneous points of view that created a disconcerting image of the model. Since we are dealing with a complex theme, a photocopy should first be made of the model, and then it can be traced with a graphite pencil. This is the only way to achieve an accurate and precise representation of each of the shapes and the lines, and of their angles.

1

2

3

1. Trace the drawing from photocopies of the model. Then go over the lines with the pencil to make them darker, since they are the guides that limit the edges of each color.

2. First, paint the background black with a soft hair brush, which will help apply the color uniformly. Then blend it with burnt sienna using gradations, brushing from the top downward.

3. The dark background outlines the main chromatic areas of the painting.

Now it is best to wait a few days for the black to dry before applying more colors, otherwise even minimal contact with the background could muddy the colors.

SILICON COLOR SHAPERS

Brushes with silicon tips can be used to move paint around, make sgraffito, and create highlights on the surface of wet oil paint.

4. Apply a layer of whitened paint in the center of the painting. Use a fine brush charged with black to add, over the wet paint, the lines and shadows of the objects that look as if they were drawn. With the end of the brush handle add some sgraffito in the layer of fresh paint.

5. Add dots on the dark parts of the background. If you dilute the paint a little with oil painting medium, the dots will be darker and be seen more easily.

6. Mix raw umber and ochre to paint the area that looks like a plank of wood. While this area is still wet, use a silicon color shaper to make sgraffito marks that suggest the grain of the wood. There are very good examples of this process in the video.

4

5

6

Chiaroscuro Effects

Next you will incorporate some very interesting textural effects like the wood grain and pointillism. Juan Gris used to represent these textures with *papers collées*, but we are going to recreate them in oils using a silicon shaper brush. The objects that make up the still life will emerge little by little as they are created using shading and modeling techniques. The elements are figurative and are easy to identify, even though they look fragmented, and each one of them is represented from a different point of view: the fruit bowl and the cup from an elevated position, the coffee pot from the side, and the newspaper completely flat. Other objects, like the coffee grinder, are so stylized that you have to use your imagination to recognize them.

7

8

7. The objects begin appearing thanks to the monochromatic work done with a fine brush. You must proceed very carefully so that you do not ruin the work by brushing it with your hand.

8. Draw the letters of the newspaper over a background of Veronese green lightened with white. Use a gray tone made by mixing Veronese green with permanent violet. Use the same mixture to add the shadows on the green background. Watch the video to see how the modeling of the objects is done on the still-wet green.

9

9. On the tablecloth, it is necessary to apply a layer of creamy white paint with a touch of ochre and gray, creating light tonal values. The shading is done with additions of gray and end with an overall sgraffito done with the handle end of the paintbrush.

It may not look like it, but in reality this is a very labor-intensive work, since most of the interventions require great precision and there is barely room for a few quick and spontaneous brushstrokes as in other paintings in this book. Nevertheless, the result is impeccable and very close to the real model.

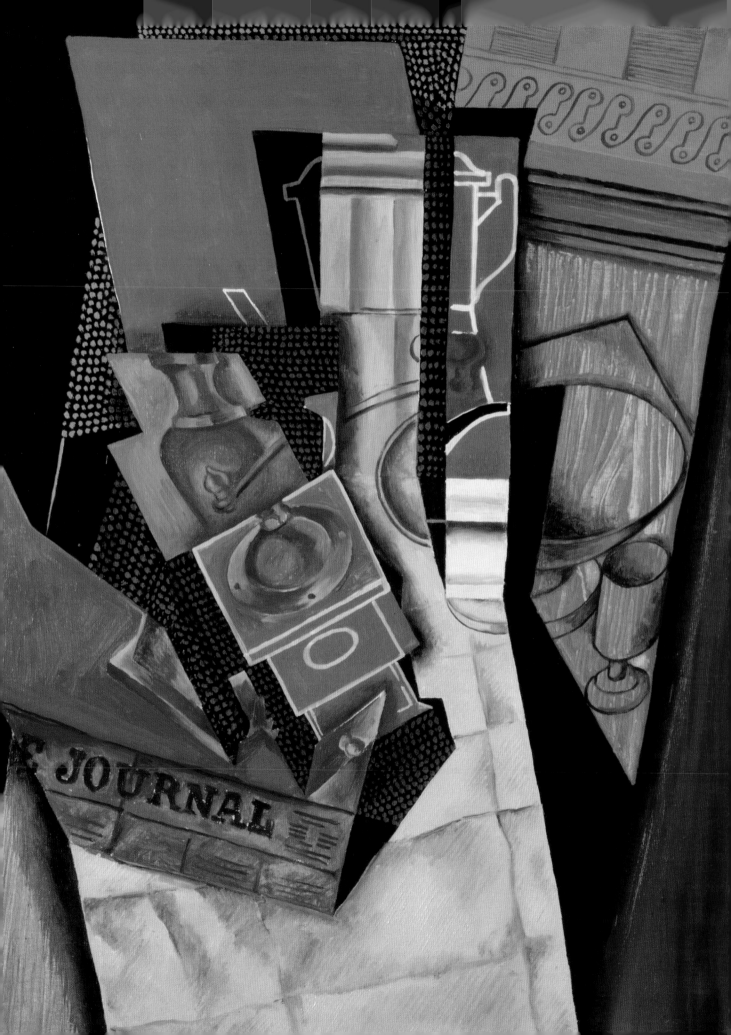

Patinas and Finishes

When you have finished the copy and the paint is completely dry, you can still slightly modify the colors by adding a patina, that is, a semitransparent covering that is applied to the surface of a painting to make it look older, to emphasize the texture, or to alter its coloring. The copying of a masterwork culminates with varnishing, a final layer of varnish that will give it an overall finish, whether uniform, glossy, satin, or matte, according to the preference of the copyist. This layer of varnish, in addition to protecting the paint from possible scratches, dust, and even humidity, also highlights the depth, saturation, and brilliance of the colors.

Applying a Patina

To mix a patina, dissolve a little oil paint or asphaltum with linseed oil and varnish. You should incorporate a small amount of siccative to this mixture to speed up the drying process.

After the painting is dry, you can apply a patina or glaze over it with the goal of giving it a film of transparent color that will modify the final tone of the painting's colors. With oil patinas, you can create effects of aging, darken the tones of the painting, and soften the saturation of the colors, thus unifying the chromatic range used in some paintings. The recipe for making a patina is very simple. First, put some drops of asphaltum or any other very diluted oil color in a bowl. Then add one part linseed oil and one part clear satin varnish. Some artists prefer to add a little cobalt drying agent, or siccative, to accelerate the drying process. This will make an oleaginous preparation that can be thinned with a little turpentine. Next, spread the patina over the painting in a thin coat.

Instead of using asphaltum, you can also dissolve in varnish any oil paint, like raw sienna, sepia, or burnt umber, and apply it as a thin patina to soften the colors that look too saturated.

The dark brown–colored asphaltum can be dissolved with varnish to create a patina that softens the intensity of the colors and adds an aged look to the surface of the painting.

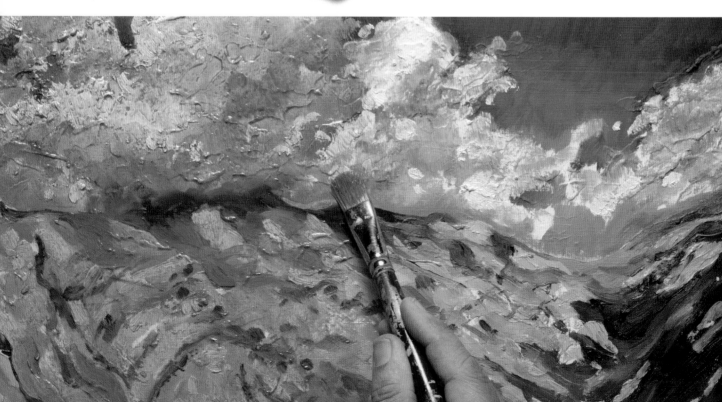

A. Spread the patina made with green oil paint over a surface treated with gesso to give it texture. You can see how the color is mainly deposited in the streaks and grooves.

B. Asphaltum makes a brown patina that is similar to the color burnt umber. You must be very careful when preparing this mixture because asphaltum has very strong staining power.

C. Yellow ochre softens the saturation of the colors in the painting while giving it a much warmer intonation. The drying of each patina takes from two to five days because linseed oil dries very slowly. This time can be reduced by half by incorporating a siccative.

The application is usually done with soft hair brushes, although a natural sponge can also be used for this purpose, and it can also be used to create interesting effects like mottling and streaking.

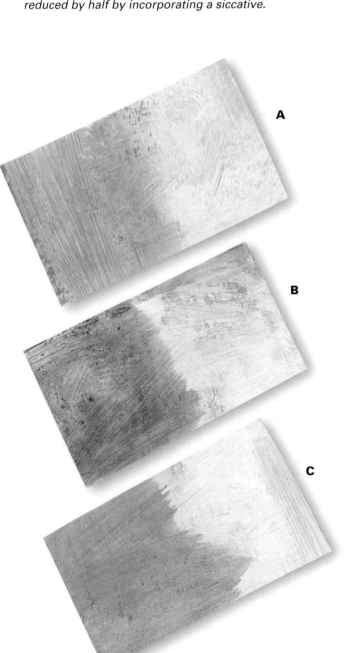

A

B

C

Put a small amount of a chosen oil color in a bowl along with a little linseed oil, varnish, and siccative. Mix them well and apply with a brush or sponge. The consistency of the preparation will be very oily.

You can also create a patina by rubbing the surface of the painting with chalk and then diluting the powdered pigment left on the surface with a little varnish mixed with oil.

Aging Effects
with Craquelure

Some copyists prefer to complete a painting by applying an aging effect that gives the work the appearance of the era that it represents, using techniques that become more sophisticated every day. But before aging a painting or trying to give it an antique look, you must be sure that it is completely dry. There are two basic ways of doing this. The first consists of adding a small amount of asphaltum to a retouching varnish and using it to cover the surface of the painting with a thin coat. Then you clean it by wiping with circular motions, using a lint-free rag. We will demonstrate the second, much more interesting, option in this section; it involves mixing aging varnish with another crackle varnish. First, apply the aging varnish in a very thin coat, allow it to dry for an hour and a half, until it is tacky, and then immediately apply the crackle varnish. In a short amount of time, the cracks will appear, and the painting will begin to look like it is old.

To create craquelure, you must use two varnishes: one to age the painting and another to make the cracks. The different drying times cause the cracking to occur on the surface of the painting.

Mixing asphaltum with varnish creates a patina that makes the painting look old by imitating the brown colors, which yellow or darken the layer of paint because of the effects of oxidation.

A. *The craquelure is produced because the top layer of varnish dries quickly; this causes it to contract, vitrify, and move much more quickly than the varnish underneath, which is still wet.*

B. *If the craquelure is too light, spread a little asphaltum or paint diluted in turpentine over it and lightly rub the surface with a rag. The pigment will build up in the cracks and the craquelure will be more visible.*

A

B

To accentuate the cracks, just blow hot air on the varnishes with a blow dryer. The upper layer will begin to crack immediately and allow you to see the base color through the scratches and specks.

The craquelure can be applied to any kind of oil-painted surface that you wish to age. It creates an antique finish that adds interest to the painting.

Varnishing the Painting

Frequently the purpose of varnishing a painting is to give it a glossy or matte finish; however, this is not its main function. The primary mission of a varnish is to protect the painting from all types of physical aggressions: scratches, fingerprints, marking with pencils or paint, etc., and to protect it from sunlight. To varnish an oil-painted copy, you must wait for at least 6 to 12 months from the time the painting is dry to the touch, not from when it was finished. The thicker the paint, the longer you will have to wait, and it is best to be patient and give it time because the proper conservation of the painting depends on it. Oil paints expand and contract as they dry, and varnishing them too soon can cause cracks because the varnish is not as flexible as the paint.

We most strongly advise against using the same brushes for varnishing that were previously used for painting because there is a risk of their releasing traces of pigment. You must use brushes reserved for varnishing only, preferably flat ones that will not lose hair.

There are two types of varnish for oil paintings: Retouching varnish, which can be applied not long after the painting has been finished, as long as the painting is dry to the touch and will temporarily protect its surface, and permanent varnish, which should be applied a year later.

Holland varnish should never be applied over a finished painting, since it is neither a varnish nor a finish. It is mixed with paint to add consistency to glazes and to accelerate drying time.

There are many brands and types of varnish, even for watercolors. Those who paint copies of master works usually prefer glossy varnish. Another option is reversible varnish, which, as its name indicates, can be removed with a solvent like essence of turpentine or mineral spirits.

The correct approach is to apply brushstrokes of varnish diluted with 10 percent turpentine in one direction to cover the entire painting, and then to do the same in the opposite direction. Varnish should be applied in very thin layers, never in a single coat of thick varnish.

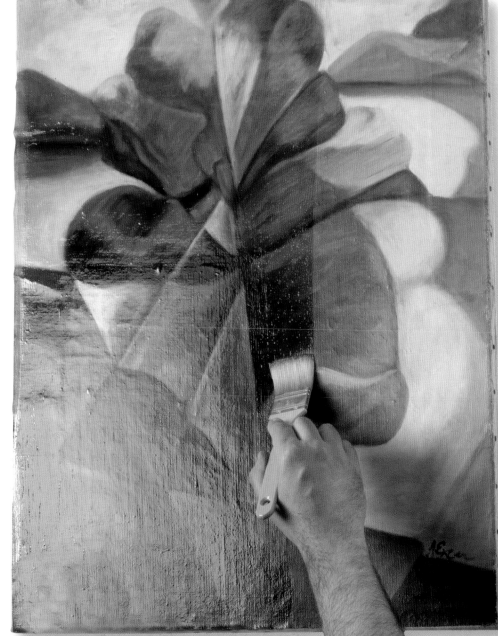

Original title of the book in Spanish:
Pintar como los grandes maestros

Design and Production:
Parramón Paidotribo

Layout:
Estudi Guasch, S.L.

Editorial Director:
María Fernanda Canal

Photography:
Nos & Soto and AGE Fotostock

Editor:
Maricarmen Ramos

Illustration:
Jaume Farrés

Text:
Gabriel Martín

Music:
Free Music Projects

Paintings:
Vicenç Ballestar, Merche Gaspar,
Gabriel Martín, and Óscar Sanchís

Production:
Sagrafic, S.L.

Prepress:
iScriptat

Collection Design:
Josep Guasch

Translated from the Spanish by Michael Brunelle and
Beatriz Cortabarria.

© Copyright 2014 Parramon Paidotribo—World Rights
Published by Parramon Paidotribo, S.L., Badalona, Spain

First edition for the United States, its territories
and dependencies, and Canada, published 2015 by
Barron's Educational Series, Inc.
English edition © 2015 by Barron's Educational Series, Inc.

All inquiries should be addressed to:
Barron's Educational Series, Inc.
250 Wireless Boulevard
Hauppauge, New York 11788
www.barronseduc.com

ISBN: 978-1-4380-0549-2

Library of Congress Control Number: 2014930732

Printed in China

9 8 7 6 5 4 3 2 1